Have Tutu, Will Travel

(The Dancing Years)

Rochelle Zide-Booth

Acknowledgments

For years, friends and colleagues have been after me to write about my life in the world of ballet. This is the first of two volumes, the one about myself as a dancer. I owe that part of my career to my teachers, especially Harriet Hoctor, Robert Joffrey, Erik Bruhn, Valentina Pereyaslavec, Leon Danielian, Vera Volkova, and Elisabeth Andersen. My parents were a constant support for me as well. For help with the work on the computer, I thank my friend Rob Weinberg. And, most of all, I've been blessed with the most supportive husband and children in the world. Without these people, this book could never have happened. Thanks to all.

Synopsis

The Day I Became an Earthling

July 5, 1965. Le Roy, a private hospital on Manhattan's upper East Side.

Jerome Rosenblatt, the doctor, standing judiciously juxtaposed between me and the window, his arms outspread in anticipation of my leap to suicide: "You might never dance again."

I, the patient, stretched out on the hospital bed: "Will I walk again?"

The next day, "They told me never to tell a dancer she couldn't dance again. You had a kind of funny smile on your face. What were you thinking when I told you?"

"I can eat a-n-y-t-h-i-n-g I want!"

Still, twenty-five years, a quarter of a century…

A Saturday in 1941. The Harriet Hoctor School of Ballet in Boston:

My mother: "But you said on the phone that you take children. That you have a children's class on Saturdays."

Miss Hoctor, the famous ballerina of the Ziegfield Follies, famous for such feats as climbing the Eiffel Tower on toe and dancing with Fred Astaire in the movie Shall We Dance: "That isn't a child. That's a toy. 'Children' are thirteen years old." I, three years old: "But I *want* to be a dancer, a ballerina, just like you – and I *will* be."

A few weeks later: The studio. A private lesson. I am too young to join the class, but not too young to dance.

" Miss Hoctor, Miss Hoctor, I remember the dance you taught me last week." To my mother: "Can babies do that?" My mother: "If she says she can, she can."

Miss Hoctor: "The older girls are going to dance at my church tonight. The audience would love to see this little one." My first performance, including my first encore. The audience loves me, but more important, I love them. I am hooked. I am a dancer.

1945. The Harriet Hoctor School of Ballet: I am six years old, still so small I wear clothes that would fit a three-year-old. Anton Dolin, the great Diaghilev Ballet dancer, is in Boston, at Miss Hoctor's studio, to cast his famous ballet Pas de Quatre. He looks down at me: "This is not a

child. This is a toy." Nevertheless, he assigns me the role of Carlota Grisi, which requires the strongest pointe technique. I am certainly the smallest who has ever danced the role, before or since.

1953. The School of American Ballet in New York City: I stand in the hallway outside the office of the Executive Director. She is meeting with all four advanced ballet teachers whose classes I have taken the past week. They are speaking Russian. An argument escalates into a shouting match. I decide to learn Russian. The famed and feared Muriel Stuart emerges from the office. It seems she has been outvoted. "You've got a scholarship," she snorts. "But you'll never get into the company because you're too short and too fat." I am fourteen years old. I don't accept the scholarship. Mother won't let me.

April 21, 1954. My sixteenth birthday. Spring vacation. The school of the Ballet Russe de Monte Carlo in New York City. The Executive Director of the school asks me if my mother is with me. Sergei Denham, the Director of the company, wants to see us. As we approach his office, I tell my mother that I know he is going to offer me a scholarship to the school and that if she doesn't let me accept it, I will run away from home. At least she'll know where to find me! I am wrong. He doesn't offer me a scholarship. He offers me a place in the company. I am to dance with the best-known ballet company in America. I may be the youngest member of the corps de ballet. I do not finish high school, but now I may learn Russian.
My first tour, October 1 through May 15. One hundred ten cities. On a bus. I love it. They give me solo parts right away. In four years, I am officially a Soloist, with a solo photo in the souvenir program. I dance leading roles almost every night.

1957: New York: Ballet Theatre School. I find a new teacher, Robert Joffrey. If I am to make the transition from teenage prodigy to ballerina, I am convinced I need him. He asks me to join his new company. Mr. Denham won't release me from my contract. On tour in Lubbock, Texas, I break my leg in a hotel ballroom rehearsal. They send me home to Boston. I can't dance for ten months. I want to die. Instead, I gain weight.

1958: New York. Again. I join the Robert Joffrey Ballet as a Principal Dancer. I weigh one hundred pounds. He thinks eighty-seven is enough for me. I subsist for four years on hard-boiled eggs and water. We tour. On a bus. *Again.* I am hungry. All the time. I fall onstage. My eyes. Detached retinas. They send me home. To Boston. The best surgeons. I can't dance for six months. I audit a course in Russian at Harvard. I learn Russian. At last. I want to die. I gain weight. Again.

1962. I am twenty-four. I am also officially a Ballerina of a company called America Dances. We tour. On a bus. Alexandra Danilova, my idol from the Ballet Russe, introduces me as America's finest young ballerina. She also suggests I consider losing weight. I am hungry. Often. When the tour is over, I join the New York City Opera as Prima Ballerina. *Yes!*

December of 1963. I meet Robert Booth at a singles' brunch at a synagogue in Manhattan. We marry. I dance for another year until I tear my Achilles tendon. Dancing. They do not send me home. I *am* home. Instead, they take me to a hospital on the upper East Side. Le Roy Hospital. I don't want to die. I want to eat. I will never dance again. I will be forever of the earth. No longer of the air. Dancers are not ordinary. I am no longer a dancer. I am ordinary. I can eat anything I want. At last, I can gain weight. But it no longer matters.

Have Tutu, Will Travel

Prologue

"I Don't *Want* to See You!"

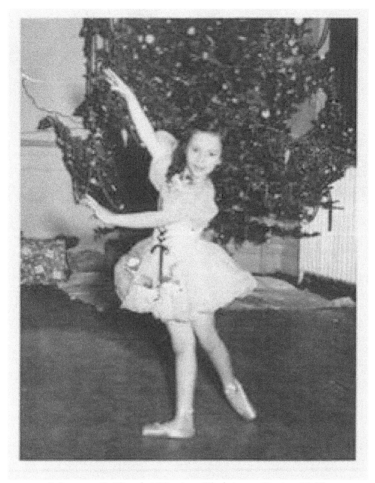

Me, age 5, Harriet Hoctor Christmas Party, 1943

You don't choose ballet. It chooses you. How else to explain that I, three years old and having seen only one performance in my whole life, decided to be a ballerina? I started with private lessons from Harriet Hoctor, who had no beginner classes at the time. The next year I was moved up to the advanced class with the fourteen-year-olds, and I choreographed my own solo for the recital. At the dress rehearsal, I noticed that there was a grand défilé at the end, comprised of all the dancers in the performance, led by the youngest. I was the only one who wasn't in it! Miss Hoctor said she thought I was too young for that kind of responsibility. Well… The night of the recital at the beautiful old Boston Opera House, I asked my mother to bring my costumes from the dressing room to the backstage so that I could watch all the dances. The next time I had a lesson, I asked Ellen Swan Haines, our pianist, to play the music to all the dances in the recital. I then danced

everything that everybody, including Miss Hoctor herself, had performed. My mother didn't look too happy, but Miss Hoctor laughed and laughed. She promised that the next year I could definitely lead the grand défilé.

At age five, I was measured for pointe shoes, which were made by "the man" from Barney's because none of the shoe manufacturers carried them that small. Why did Miss Hoctor put me on pointe so young? Because my mother told her that I was dancing around the house on toe – in my bare feet – and they were both worried that I would hurt myself. Miss Hoctor was a very smart lady. She made me sign a contract that read that I would only dance on toe in my pointe shoes – and she kept the shoes at the studio!

When I was six, Miss Hoctor invited the famous Diaghilev Ballet dancer Anton Dolin to judge the Advanced Class for the Barre Work prize, awarded to the student who demonstrated the most nearly correct barre work in the school. I was the youngest ever to win it. The prize consisted of two parts: The Complete Book of Ballets by Cyril Beaumont, autographed by Miss Hoctor, and the chance to teach barre work to the 'baby class' for a whole year. Miss Hoctor, thinking I was too young to do that, explained that she would award that part of the prize to the girl who came in second. It was Rose Marie Arena, my favorite among the older girls. I insisted that I'd won the prize and that I wanted to teach the class. Unbelievably, she let me. At the end of the year, I told my mother that I knew I was going to teach after I finished dancing because I liked it so much. Mr. Dolin also staged the most famous ballet he had choreographed, *Pas de Quatre,* for us, and I, at age six, was chosen by him to portray Carlotta Grisi!

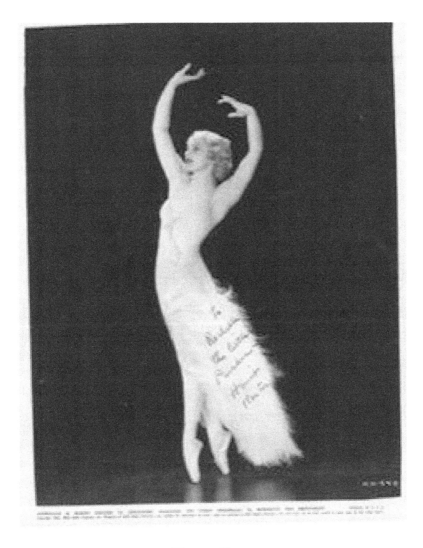

Harriet Hoctor

None of Miss Hoctor's students can remember her teaching us how to do anything. We just watched her and tried to do what she did. There was great joy in that studio and, yes, magic as well. We actually believed we could do anything she asked of us! For instance, we had to be able to turn the same number of pirouettes as our ages. So, since I was five when I got my pointe shoes, my first pirouettes on pointe were quintuplets – Miss Hoctor had simply told me that whatever I used to do on half-pointe, I was now to do on pointe. That was the way she taught.

A year later, my mother realized that Miss Hoctor probably could not prepare me for a classical ballet company, so she took me to New York, the center of ballet in America at that time, to do some research into good teachers. The most professional school was Ballet Arts at Carnegie Hall. Virginia Lee, the Director of the school, didn't believe that I was seven years old: I was the size of a three-year-old. She placed me in Natalie Branitzka's (a Diaghilev ballerina) baby class. When

she gave pirouettes, the other children were struggling to do quarter turns while I was doing my seven – I was, after all, seven years old. Madame deposited me with Miss Lee with instructions that I was to try Lisan Kay's children's class. Afterward, Miss Kay asked me to take her pointe class, whose star pupil was a twelve-year-old beauty named Jill Zimmerman. As Jillana, she later became a ballerina of the New York City Ballet. After that class, Miss Kay told Miss Lee to put me in the professional class, whatever the fallout from the other students and teachers might be.

That week was wonderful. Dancers in my classes were stars of the Ballet Russe and American Ballet Theatre, and among the teachers were Margaret Craske and Edward Caton. But my first class was taught by Antony Tudor, who was *not* pleased to have a child in his class. He placed me right behind a lady with a big bottom. My head came about to the middle of it, and every time I tried to peek out to see what the combination was, he said, "I don't *want* to see you." Afterwards, I told my mother about the lady and her big bottom just as she happened to walk by. When she turned to glare at me, my mother said, "Oh, my God, that's Agnes de Mille!"

The Boston teacher that was recommended to my mother was Alicia Langford, with whom I studied for a year. I think she was a very good teacher, but there was no joy, no magic in her classes. In fact, the whole time I was there, I felt as if I were in a straitjacket. She even took away my pirouettes, insisting that I do no more than singles. I just wasn't ready, at age seven, for so much discipline and so little fun. At the end of the year, I told my mother that if this was what you had to do to be a dancer, I didn't want to be one any more. Mother's solution was to stop my lessons completely for a while. During that summer, I got interested in baseball and became a lifelong Boston Red Sox fan, but when fall came, I was devastated. No baseball, no ballet, so I came up with a creative plan.

I scoured the telephone book for dancing schools in downtown Boston, which was easily accessible by streetcar, and found one listed under Diane Rhodes, a young woman who had danced with the Ballet Russe. Then, instead of eating, I saved my lunch money every day at school. That gave me $2.50 at the end of each week. I told my mother I needed carfare to the library in Boston for a school project I was working on and set off on Saturdays for my lessons with Diane. Not only did I take her ballet class, but she invited me to watch a modern dance class with a guest teacher from New York. I sat under the piano and watched the great José Limon teach every week for six weeks.

At the end of that time, Diane called me in to her office to tell me she was afraid she'd gotten me into trouble. She'd telephoned my mother to tell her that I was too talented to be taking only one class a week. Since that was all she taught, she wanted us to look for another teacher. My mother said, "Who is this? My daughter is at the library". I thought she would be furious with me, but when I got home, all she said was, "If you want it that much, we have to find you the right teacher."

Back to New York. Back to Ballet Arts, where this time I studied with Vladimir Dokoudovsky. He was so handsome that the other girls – all much older than me – were in love with him. He taught technique and repertory, and I learned the opening scene of Petrouchka and the 'mad scene' from Giselle that week. He assigned the tallest, best-looking young man to be my partner. It was Nikolai Polajenko who definitely didn't want to dance with a child, but Dokoudovsky insisted and had us demonstrate for the whole class. He couldn't understand how I had just the right 'look' for the 'mad scene,' and I wasn't about to tell him it was just my usual without-my-glasses myopic stare. One of the other dancers in his class was Leslie Caron. She was a beautiful dancer and a lovely person.

At Steinway Hall, I studied with Anatole Vilzak and Ludmilla Schollar of the Diaghilev Ballet. Their classes were wonderful. She taught the original Petipa variations and beautiful pointe classes, and he taught ballet classes like Miss Hoctor's. He used to say, "You promised me twelve pirouettes, Madame," and I would knock myself out trying to do them for him. There was a beautiful young girl there, about five years older than me, who was living with them while her father, Nicolas Beriozov, worked as a ballet master in England. I wished I looked like her, and she said she wished she could dance like me! They were all especially impressed with my pirouettes – thank you, Miss Hoctor. Oh, yes, that young girl grew up to be Svetlana Beriosova, ballerina of England's Royal Ballet.

I also took private lessons from George Chaffée at his studio on 56th street. He taught me the last step I ever learned, the gargouillade – a 'gargling' of the feet – and told me lots of stories about Anna Pavlova, with whose company he had danced. He also put a half-full glass of wine on my turned out foot as my leg was stretched at hip level in front of me and made me do a *rond de jambe* - leg circle – to second position without dropping the glass or spilling the wine. He had an uncanny way of knowing just when to grab it off my foot! He also recommended E. Virginia Williams, who later founded the Boston Ballet, as my new Boston teacher.

I spent the next five years at her Boston School of Ballet, both in Boston and on the ground floor of her house in Malden. It took an hour and a half to get to Malden from my school in Brookline: by streetcar to North Station, on the elevated to Everett Station (where I bought six glazed doughnuts), by bus (where I ate the six glazed doughnuts) to Malden Square, and a half mile walk to 614 Main Street. When Virginia told me to lose weight, I simply stopped buying the doughnuts. She thought it was amazing that I could lose weight so quickly! That journey from school to the studio was the beginning of my real love for dance. When I boarded the streetcar, my life was, like the beginning of the movie The Secret Garden, in black and white. As I got closer to Malden, it was like the opening of the garden gate in the film, in technicolor. I loved everything about ballet: classes, rehearsals, performances – all of it. From the age of nine to fourteen, I took eighteen lessons a week after school. It was a mix of ballet and pointe classes plus tap, jazz, acrobatic, acrobatic adagio and *pas de deux*. I even learned baton twirling. On the seventh day, we didn't rest – we rehearsed. My agreement with my mother was that every time a school grade slipped from the expected A, I would forfeit a class. Needless to say, my grades never slipped.

Every year, Virginia took a group of us to New York on school vacations and for two weeks in the summer. She charged each of us $60 a week. That paid for train fare on a sleeper, classes, and all our meals. She gave us a dollar a day for the meals. We ate breakfast at the Automat – I remember it was 17 cents for a bowl of cereal and a glass of milk. Lunch at Nedick's was 25 cents for two hot dogs and an orange drink. Dinner was at Romeo's, where spaghetti, meat balls, garlic bread, and a soft drink were 35 cents. I saved the rest of the money so that the day before we left, I could buy a book at Kamin's Dance Book Shop. We also visited the Metropolitan Museum of Art, other museums and went to performances of ballet and musical theater.

Virginia sent us off every morning, two by two, to all the well-known ballet schools: Ballet Arts, School of American Ballet (SAB), Chaffée, Maestro Vincenzo Celli, Mme. Branitzka (she had her own school by then), Vilzak and Schollar, and Tatiana Chamié. I was allowed to go by myself because I remembered the combinations of steps from all the classes. The others helped each other – and Virginia recorded everything by longhand in separate notebooks. Later, she made her reputation by hiring the best-known teachers, like Anatole Oboukhov from SAB, renting a studio, and having them teach us privately. They were always surprised at how quickly we picked up their combinations. What they didn't know was that we'd been doing their classes at home for weeks to prepare – and they all thought that Virginia was an extraordinary teacher!

One day, when I was about eleven, we all went out to lunch at the Automat on 57th Street. A man came over to our table, said he'd seen us in Mr. Vilzak's class across the street at Steinway Hall and asked Virginia if she was our teacher. He then asked me how long I'd been studying. Thinking it would please her, I said "two years," which was how long I'd been her pupil. She looked at me and said, "Why do you think this man asked about you? Because he thinks you're talented. Do you know why that is? Because you're the only one who studied with Harriet Hoctor. I can't do what she does – I wish I could - but don't you ever forget her and what you learned from her." I never did after that.

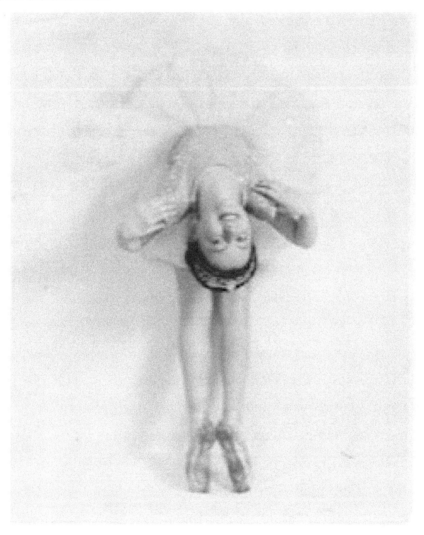

Me in the famous Harriet Hoctor backbend

My mother came with us one time when Virginia sent us to the studio of Joseph Pilates – yes, the Pilates who designed all the exercises people are doing today. Virginia was an excellent

acrobatics teacher (what we today call gymnastics), and she wanted Joe to help us – and her – with some movements, specifically aerials. Aerials are flips forward or backward or sideways without hands touching the floor. Joe worked with us individually on the machines he had designed and built for just that purpose. When my mother arrived at his studio to pick me up, she saw me practicing, and I was high off the floor. "Stop! Get out of those straps. You want to be a classical ballet dancer. You're never to do this again." And she pulled me away from the great Joe Pilates and took me to lunch.

In addition to the New York trips, Virginia also brought in guest teachers every time a ballet company, usually the Ballet Russe, played in Boston. We had classes from the ballerinas Alexandra Danilova and Ruthanna Boris and the soloist Alan Howard, among others. I remember Ruthanna screaming at me, "Straighten your knees!" and they snapped into place. Virginia said, "I've been giving her that correction for two years." It must have been Ruthanna's New York accent.

When I was twelve, Virginia gave me a choice for the recital, either a ballet she was going to choreograph or The Nutcracker, to be staged by Mme. Danilova. Naturally, I chose to work with the great Russian ballerina. As it happened, on my 13th birthday, late in April, I had an attack of appendicitis and was operated on at midnight. When my mother arrived at the hospital early the next morning, I was standing up, holding on to the nightstand. Mother said, "Don't tell me you're doing pliés." "No, battements tendus". (They don't involve any bending.)

The recital was only two months later, but I was able to dance Clara, the Snow Queen, and the Sugar Plum Fairy – all the leading roles - in The Nutcracker as well as some pieces of Virginia's choreography. The next year, I was asked if I wanted to do Virginia's Cinderella or Danilova's staging of the Ballet Russe Coppélia. My choice didn't endear me to my teacher, but, really, how could I pass up a chance to work with Danilova on another of her great roles?

At the end of that year, I decided to go back to Miss Hoctor to try to recapture the magic that you could only find at her studio. My mother agreed as long as I would work with more classical teachers as well. The next two years were wonderful: I studied with Tatiana Stepanova, a second generation 'baby ballerina' of the Original Ballet Russe, who made me technically very strong; Margaret Saul, an expert in the Cecchetti method who taught his technique plus character and mime; and Miss Hoctor – all at the same time. For a few very special weeks, Leon Danielian, a star of the Ballet Russe, gave guest classes at a studio near my home, and I took them every

Saturday. They were fun, and he was very attentive to me, giving me the kind of corrections I'd never had before, working especially on balance and placement.

Leon Danielian

That year, England's Royal Ballet came to town, looking for 'supers' (supernumeraries or extras). My friend Walda Welch and I rushed to the old Boston Opera House and were accepted. In the choreographer Frederic Ashton's Sylvia, Walda and I stood by a large door and, at the appropriate moment in the ballet, we had to pull it open so that the great Margot Fonteyn could make her entrance. The door turned out to be too heavy for us, and, try as we might, we couldn't get it open. Miss Fonteyn had to push it herself. We were so embarrassed! But she was very gracious about it, and we worked at it until we got it right at the next performance.

We were also Pages in the first act of The Sleeping Beauty and Monkey Pages in the last act. Each of us had to carry on a tree and sit on the floor behind it with our legs crossed around the trunk so that Little Red Riding Hood could be concealed when the Wolf was chasing her. That

didn't sound too hard, but…. my stockings, which were rolled up to the knee, were much too big for me and kept falling down. I really had my hands full, what with carrying that tree *and* trying to hold up my stockings. In the corps de ballet dressing room, the dancers laughed about me for days.

The best thing about that week, in addition to being able to watch Fonteyn, Moira Shearer (of The Red Shoes fame), and all the other dancers, was what happened before performances. Walda and I went early to the theater, changed into our practice clothes, and started to do barre onstage. As it happened, Bryan Shaw and Alexander Grant, two of the company's most exciting soloists, were doing barre, too. They invited us to join them! Then we four did some fun things in the center: jumps and pirouettes and traveling combinations. They asked us to work with them every day. When the lady in charge of the 'supers' tried to pay us (two dollars per performance), I said I couldn't take the money because the experience was so incredible for me, but she said I had to because it had been budgeted.

Tatiana Chamié

I also kept going to New York on school vacations. One time, at Mme Chamié's little studio, Melissa Hayden, ballerina of the New York City Ballet, was in class. She was very pregnant with her first child. Chamié was nervous about her doing jumps. After class, Millie asked if she could use the phone, and we heard her call her husband, Don, and tell him to get the little suitcase from

under the bed and meet her at the hospital. She then said, "about every three minutes." Needless to say, Chamié rushed her into a taxi and sent her on her way. Only a few weeks later, Millie was back onstage at the City Center, dancing with the New York City Ballet.

Another time, two Broadway 'gypsies' took class and asked to speak to me afterward. They were helping Jerome Robbins cast a new Broadway show called The King and I and wanted to recommend me to him to play one of the king's children. My mother said, "NO." I was too young. Just think – I could have been onstage with Yul Brynner and Sal Mineo! She also said "NO" when the producers of The Unfinished Dance wanted me to be the dancing double for Margaret O'Brien in the film. I did look a lot like her.

Another day, a young man showed up for Mme Chamié's class for the first time. I'd never seen anyone so beautiful in my whole life. I stood right behind him at the barre and was amazed at his turnout and extension, all the while telling myself that with so much flexibility, he probably couldn't turn or jump very well. Wrong! Whatever she asked for (I remember six pirouettes right and left), he was able to do. As for jumps – he actually scraped his knuckles on her (admittedly low) ceiling. That did it – she called her friend Sergei Denham, Director of the Ballet Russe, and arranged for him to watch class the next evening. When that class was over, Denham said, "Well, Tania, you know we already have a lot of blond men." Here was the greatest male dancer I'd ever seen, and Denham was worried about his hair color. Chamié just picked up the phone, called Ballet Theatre, and said to their Director, "Lucia, I have a blond boy." Lucia took him sight unseen. That was Erik Bruhn, and he really was the greatest dancer I've ever seen.

Erik Bruhn

When the Ballet Russe School opened its doors in New York, I spent my February school vacation there, taking classes from Frederic Franklin. Then, during Easter vacation, I was back: Monday, I took Mr. Franklin's class. Tuesday, Mr. Denham and Mme. Danilova watched class. Wednesday, the Executive Director of the school said that Mr. Denham wanted to see me and my mother at the Ballet Russe office, and she suggested that we walk over there immediately. We did. When he offered me a contract, Mother said we'd sign it first and *THEN* call my Dad. Mother asked Mr. Denham how I'd finish high school. It was, after all, only my sixteenth birthday. By correspondence. She also asked who would take care of me. Mr. Denham said he would assign an older girl to do so. Then I asked Mr. Denham the important (to me) question, "How did you know about me?" He said that before Mme. Chamié died in 1955, she left him a list of dancers to watch for. My name was at the top of that list. I was also on lists provided by Leon Danielian (those wonderful classes in Boston) and Frederic Franklin (the February classes at the Ballet Russe School in New York).

Act 1

The Ballet Russe de Monte Carlo

"My Life Begins"

So reads my diary entry of July 12, 1954. Rehearsals for the 1954/55 Ballet Russet tour began that day at Palm Gardens, a dance hall on New York's 52nd Street. It was a huge space with a little stage at one end. The floor was always slippery because they polished it every Saturday afternoon in time for the ballroom dancers who used it that night. Our schedule: class from 9:30-11:00, rehearsal from 11-1, lunch from 1-2, rehearsal from 2-5, and sometimes, at the Ballet Russe School from 6-8. New York in July is oppressively hot and humid, and with all those hours, I quickly lost weight – eighteen pounds! I was too hot and too tired to eat, much less to cook anything. I weighed 87 pounds. I was living at the Great Northern Hotel with the wife of a rabbi and her daughter Yonah, whom I had met when we were both dance students at Ballet Theater School. Sometimes dancers from the Ballet Russe spent some time with us and our air conditioning! The first week of rehearsals, we learned a ballet every day, never reviewing them again at all. When the Call Sheet was posted on Friday with our schedule for Saturday's rehearsals, we were horrified to see a different ballet scheduled for each of the five hours. That night, we ordered urns of coffee and sandwiches to my hotel room as several of the dancers joined me to review all those ballets. Needless to say, we may have looked tired, but we were the ones who "remembered" what we had learned that week!

We had a real celebrity in the corps de ballet, although we didn't know it right away. Her name was Jenifer Heyward. She was the daughter of DuBose Heyward, the librettist of the Gershwin opera Porgy and Bess. She was a sweet, pretty Southern girl with a good body for dance. But she didn't have an easy time of it. One night, in her hometown, as luck would have it, with her friends and relatives in the audience, she slipped (oh, those icy floors!) and fell in one of the big circle dances in Swan Lake. The rest of us couldn't stop to help her up. We simply jumped over or around her until we arrived at our individual places, leaving her to gather herself and run, very late, to her own place in line. When Shirley Haynes, our ballet mistress, came backstage afterward and said, "Jenifer, you fell!" the kind of constructive criticism we received in the Ballet Russe, Jenifer's answer was, "I did?"

Another night, also in Swan Lake, on a stage that was really too small to accommodate the sixteen girls in the corps de ballet, Jenifer was standing, beautifully swanlike, right in front of Miss Tallchief's entrance wing. The middle of the stage was empty; the orchestra was quiet; the audience

was hushed. Suddenly Tallchief could be heard from the wings, "Jenifer, move downstage. I can't make my entrance." Jenifer, turning her head and body so that she looked not at all like a swan, was heard to say, "What, Miss Tallchief?" Tallchief, "Move downstage!" Jenifer, finally understanding the problem, shuffled a few feet forward (not at all unlike a swan, clumsy, out of water) and again turned her head toward the wings. "Is this all right, Miss Tallchief?" So much for the magic of the moment. Jenifer lasted only one year with the company.

Mr. Franklin taught us all the repertoire we needed to know for the tour – fifteen ballets – in less than three months and with an almost entirely new company. He was also Premier Danseur of the company, with his own responsibilities as a dancer. Freddie was amazing. He was also human, and, occasionally, he slipped up, as, for instance, in the matter of The Nutcracker. I was cast in my first solo role as the Doll in Act One. My partner in the dance was Teri De Mari. Mr. Franklin staged the party scene up to our pas de deux, took the union-required five-minute break, and picked up the scene from "after the Dolls." That became the buzzword for the entire three months of rehearsal. We would do the scene up to Teri and me and then, "Let's take it from after the Dolls." Freddie kept promising he would make a special rehearsal to teach the dance to us, but somehow that never happened.

Dolls in "Nutcracker" Act 1

The Nutcracker was scheduled for the second performance of my first tour, a matinée in Baltimore, sandwiched between Les Sylphides and Le Beau Danube. My grandfather was visiting relatives there and planned to attend my big night. Teri and I got to the theater early to try and figure out what to do. Teri was NOT going to talk to Mr. Franklin about it, fearing to jeopardize his position. He was already doing some solo roles, but I had nothing to lose. I knocked on Freddie's dressing room door. "Mr. Franklin, if you'll just hum the music for us (there were two Doll dances – which were we doing?), Teri and I will make up a dance." After he had slapped his head and said, "Borje moi (the Russian equivalent of Dammit!)," he put on his dressing gown, joined Teri and me onstage, indeed hummed the music, and, one hour before we performed it, taught us the dance.

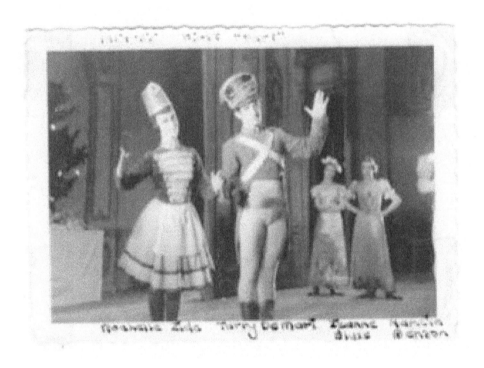

Me, Teri DeMari, Jeanne Elyse, Nancy Benson, "Nutcracker" Act 1

My friend Walda Welch said that's when she knew she was not cut out to be a professional dancer: she could never have dared to learn anything that fast and perform it immediately. She stayed only one year in the company, too.

That experience led to my being the 'go-to girl' who filled in whenever anyone was ill or injured, as in "Chellie knows it." The next time it happened was that same night in Scheherazade. One of our girls hadn't come on the tour because, as they told us younger girls, she had 'food

poisoning.' Later, one of the older girls told us she had had a 'miscarriage,' a euphemism in those pre-Roe v Wade days for an abortion. Anyway, Mr. Franklin asked me if I could do her part. Could I! Scheherazade was supposed to be my 'free' ballet – Mr. Franklin gave us young girls at least one of those – but Scheherazade looked like so much fun. When I came offstage at the end of the ballet that night, Freddie collared me and asked, "How old are you REALLY?" I guess he had thought I was too young to play a 'pink wife' (they're the 'sexy' ones) so convincingly. He then asked how I had known that I was the one who had to jump over the pearls that Zobeide had thrown at the Eunuch. He knew that I couldn't have seen them – my eyesight was too weak. I said, "Mr. Franklin, you told me to learn everyone's part, so..." From him, ironically, "If the Favorite Slave (Vaslav Nijinsky's famous role) got hurt, I suppose you could do that too?" "If you could help me with the Death Dive – I haven't figured that out yet – I'm pretty sure I could." What I didn't tell him was that I had a huge crush on Eugene Slavin, so I had learned everything his partners did in every ballet, and it was his 'wife' that I was replacing that night!

The opening night of the tour was so exciting for me: dancing onstage with Maria Tallchief in Swan Lake; having a little solo in The Mikado; and being a waitress in Gaité Parisienne with Franklin, Nina Novak, and Leon Danielian – I almost fainted when Danielian put his hat on my upraised foot as I did a backbend in the cancan! We hadn't rehearsed THAT! I didn't think about it at the time, but they must already have been grooming me for advancement. Whenever you are in a group of less than sixteen, you can congratulate yourself: I was one of four waitresses in Gaité Parisienne; one of six friends in Coppélia and Giselle; the Doll in The Nutcracker; the youngest sister in Le Beau Danube; Clara in The Nutcracker; one of two Doctor's Assistants in The Mute Wife; one of two Blackamoors in Harlequinade; and one of two girls in the Pas de Trois in Raymonda. I was also thrilled to be one of the six small girls in George Balanchine's Ballet Imperial.

The youngest sister in Le Beau Danube was a role that stuck with me for the four years that I was a member of the Ballet Russe. I had a wonderful mime scene and was allowed to choreograph my own 'business' (as I did with Clara and in Harlequinade), but after a while, I wanted to move on to more challenging dance roles in the ballet. When that didn't happen (Mr. Denham kept saying I was "the best little girl they'd ever had"), I began to invent more and more and more. Mme. Danilova attended a performance in Dallas, came backstage, and read the riot act to my 'sister' and me. She said Mr. Massine would be furious with us for disrupting his ballet with our 'business.'

Then she pulled me aside and said, "Don't change a thing. I couldn't stop watching you and laughing – you were the best thing in the ballet tonight. But you mustn't tell anyone I said that."

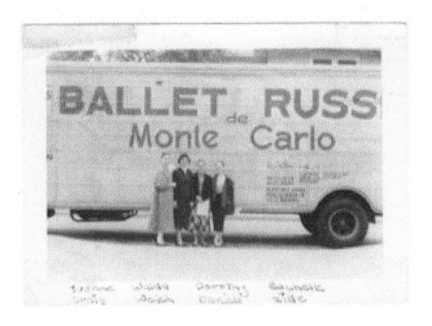

The Bus, Yvonne Craig, Walda Welch, Dorothy Daniels, Me

That first tour started in Baltimore on September 30, 1954, and ended in mid-May of 1955 in Montreal, Canada: 110 cities on a bus, mostly one-night stands. One of the girls came down with German measles, and I caught it in Montreal, so we whitened my face with make-up, and I covered myself with a shawl and pretended to be asleep at the border crossing in order not to be quarantined. My parents had driven up, and as soon as we were on U.S. soil, I transferred to their car for the drive home to Boston.

Maria Tallchief, one of the five Native American ballerinas of that time, was a wonderful role model on the tour. She rode the bus with us every day and talked to us about Mr. Balanchine and about her career. She taught me privately how to sew the elastics on my pointe shoes so that they wouldn't fray, and when she realized that we weren't getting any organized classes because Mr. Franklin was preparing himself for his own performances, she had the bus driver take her directly to the theater (instead of to the hotel to check into her room). She did her own warm-up and then taught a class for us before dancing her leading roles in the evening's ballets. She was also amazing on the bus. When we'd pass a house with nice landscaping, she would tell us the Latin names of all the plants and what their medicinal uses were. When we asked her where she'd learned all that, she said, "Well, I'm an Indian, after all!"

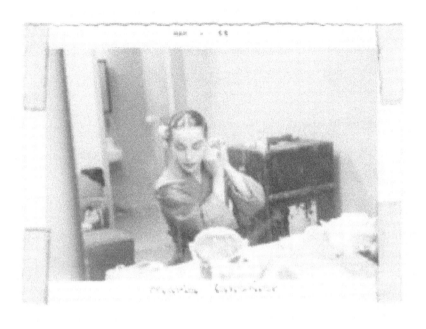

Maria Tallchief in her dressing room

Deni Lamont, one of our most talented boys, was practicing a very difficult step just before performance in Philadelphia when he landed incorrectly and broke his foot. Freddie asked me, "Chellie, can you do Deni's role in <u>Capriccio Espagnol</u> tonight?" (<u>Capriccio</u> was also supposed to be a 'free' ballet for me.) "Sure." Turning me around and looking me over, he said, "Well, the costume will hide you – I hope." (I was rather short and well-endowed for a ballet dancer.) When I came onstage to begin the ballet, Freddie asked, "What have you done to your face?" I had drawn on sideburns and a mustache to make me look more like a boy. "Take them off immediately! I'm hoping the audience won't notice you at all." The male partner with whom I was to do the 'stick dance' was at least nine inches taller than me – a big reach for both of us. My female partner was also taller. While we were doing concentric circles at the end of the finale, I suddenly remembered that the last pose in the ballet was a 'shoulder sit.' There was no way that I was going to be able to lift Kiki onto my shoulder and hold her there. Dancing around the circle, I kept calling out, "Kiki! Kiki!". We finally passed each other, and I shouted out that we'd have to improvise the last pose. When we got there, I went down on one knee, and she put her foot on the other leg. As soon as the curtain came down, Freddie looked around to see what we'd done and instructed the couple on the other end of the line to do the same thing the next time.

At a performance in St. Louis, the boys' dressing room didn't get the call for "places, please" (their backstage pager wasn't working properly), and I wound up doing a big solo, circling the

stage alone where there should have been eight of us (we'd heard the announcement in our dressing room). Freddie was NOT a happy camper that night.

The first week or so of that tour was especially memorable for several reasons, in addition to the excitement of actually being onstage with the great Ballet Russe de Monte Carlo. For one thing, we took a train from Washington D.C. to New York City, instead of the bus, because of a rush on costume fittings at Barbara Karinska's for Leonide Massine's new ballet Harold in Italy. We were each given a couchette on the train, a tiny sleeping room, and my friend Eleanor and I were put across the corridor from each other. We must have looked ridiculous in our matching sleeping outfits: red and white night shirts with red slippers and nightcaps with a little fuzzy ball dangling from the end of each one. Ellie and I hardly slept at all because of the activity in the corridor. First, we heard an almost whispered "Eugene," followed by footsteps along the corridor. That was Miss Tyven's voice, and Eugene was off to her room. A while later, it was "Genia" in a much stronger voice, Miss Tallchief's, to be sure. There went Eugene to the other end of the corridor. This continued all night long. Ellie and I, the youngest members of the company, decided that with all his extracurricular activities, we didn't know how Eugene had enough energy to DANCE! And he was only eighteen years old, much younger than those ballerinas. But that extra-curricular activity must have been what got him major solo roles dancing with those ballerinas: he wasn't really ready for them.

The costume fittings at Karinska's were a revelation to me. She would put her fingers into the waistband of your costume and ask if you could breathe. If you answered "yes," she tightened the waist another inch or two. The costumes almost didn't make it to the opening performance in Boston. We had already changed the order of the program because they weren't there in time, but Madame Karinska flew in by plane and arrived in a taxi, costumes in arms, during the intermission before we were to begin the ballet. There were still straight pins in them, and they stuck us and made us bleed. (Fortunately, the bodices were a deep burgundy, so the blood didn't show.) But they looked beautiful and fit like our second skin.

Working with Leonide Massine was like a dream come true. I loved his demi-caractere ballets, but I'd never seen one of his symphonic ballets. This one, Harold in Italy, was actually being created on us by the man who was a direct link to Diaghilev's Ballets Russes! The piece, to the music of Hector Berlioz, consisted of four sections. I was one of the 'happy couples' in the first scene, one of only two girls (plus the solo couple) in the third scene, and a 'captive' in the fourth.

26

In the first scene, when Massine asked who liked to jump, I immediately raised my hand. He looked me over and found me suitable if a little thin. After all, I weighed only 87 pounds! My partner was not happy – he wasn't much of a jumper – but we were given a little duet, much to Mr. Franklin's dismay. He wanted all the little solo bits to go to the girls with more seniority. Too bad. The first time we ran the first scene, I was the only one of the twelve dancers to enter on time. Mr. Massine asked me on what count I had entered. I wasn't about to tell Leonide Massine that I didn't count, that I just waited for the music to swell until it carried me on. I had bought a recording of the music and listened to it every night in bed, but I made up a number – 28 – and he told me to go to each of the wings to let the others know when it was almost time. You can just imagine how thrilled all the more experienced dancers were with me!

The performances at the old Boston Opera House were wonderful for me. I stayed at home instead of in a hotel, and my parents, grandfather, and lots of my friends from Brookline High School came to see me dance. Even some of my teachers came. On opening night, I was so excited that I forgot to breathe, and I fainted after Gaité Parisienne – right into Eugene's arms. How did I manage that? I also stopped writing in my journal at that time – too tired. Maybe that's why I stopped doing my high school correspondence course as well – definitely too tired. Besides, why study geography when you're living it? Although we slept in hotels every night, our real home was the bus, where we spent most of our time getting to know one another, catching up on sleep, watching the guys play poker, answering dance history questions from principal dancer Alan Howard, seeing the landscape fly by, making up songs. Songs? How about:

(to the melody of I've Been Workin' on the Railroad):

I've been dancin' in the Ballet Russe de Monte Carlo, all the livelong day.

I've been dancin' in the Ballet Russe de Monte Carlo just to pass the time away.

Can't you hear Freddie Franklin screaming, "Girls, get in that line"?

Can't you hear Freddie Franklin screaming, "Can't you dance in time"?

Someone's in the theater with Rachel. (Chapman, the company pianist)

Someone's in the theater I know-o-o-o.

Someone's in the theater with Rachel

Bangin' on the old piano.

Swan Lake, Mikado, Gaité,

Sylphides, Scheherazade too-oo-oo-oo.

Swan Lake, Mikado, Gaité, (pause)

And in the middle we'll stick Don Q!

OR

(to a theme from Giselle, Act 2):

We are divine because we stay in li-ine.

See how we bend – thank God it's near the end.

AND

(to a melody from Swan Lake, Act 2

I'm a swan queen; don't come near me

Or some evil man will shoot you, dearie,

Stay away – or you'll be gone forever…

(The older girls' version was):

I'm a swan queen, I'm a swan queen.

Stay away from me, I don't like gay boys.

Stay away, or you'll be gone forever, gone forever…

Speaking of gay boys, about half of them were gay, and half (mostly the South Americans) were rampantly heterosexual. All of them were unfailingly good and kind, especially protective of us young girls. One of them told me that when he got into the company, the South Americans sat him down as we girls danced in class and told him "okay" or "don't think of it – jail bait." The United States had a law called the Mann Act which prohibited older men from traveling across state lines with younger girls for illicit purposes. And I just thought I wasn't pretty enough for any

28

of them to want to date me! My roommate, Yvonne Craig, later the Bat Girl of television fame, didn't seem to have that problem!

The touring was a little like the Broadway musical <u>Brigadoon</u> – we surfaced in a town or city, left the next day, and didn't see it again for a year. But what fun we had!

Nina Novak's Bus Christmas Window

We even decorated our windows and seats in the bus for Christmas – and gave a prize for the best ones. Miss Novak, our resident ballerina, usually won. We did spend ten days in Chicago between Christmas and New Years every year, so our mothers would come and stay in our hotel. Since the whole company was housed on the same floor, we opened the connecting doors between rooms, decorated Christmas trees, sang Christmas carols, and gave each other presents. It really was like a huge family celebration, and we looked forward to it every year. On New Year's Eve, Mr. Denham gave a party for all of us at the Pump Room of the Ambassador East Hotel, a real dress-up affair with flaming skewers of food, champagne, and an orchestra to dance to. Mr. Denham even danced with me!

My infatuation with Eugene lasted all four years I was with the company. Nothing ever came of that until years later when I adjudicated the Southwest Regional Ballet Festival. Eugene was then the Artistic Director of Ballet Austin in Texas. He had choreographed several pieces for me to judge, and when I reached over to tell him how good they were, his hands were like ice. "What's the matter, Eugene?" I asked. "I'm so nervous," he said. All I could think of was, "YES!!"

He didn't know it, but he had gotten me into trouble with my mother when we were both in the Ballet Russe. Several of the South American dancers and their wives/girlfriends often went out together. I was 'dating' one of the men only because it brought me into proximity with Eugene. I didn't realize that my 'date' was using me to cover up his relationship with one of the older girls. (More about that later.) At the Top of the Mark, a restaurant in the Mark Hopkins Hotel in San Francisco, we all ordered drinks. Eugene and I were too young – you had to be 21. I was still 16, and he was only 18. The maitre d' took his whiskey away but left my drink because it looked like lemonade. (It was actually a rum collins.) When I wrote my mother about the incident, having previously written her that I'd tasted my first such drink at a party, I received a telegram at the hotel: "Phone home at once"! I was worried that something had happened to my grandfather, who lived with my parents, so I called right away. Here's how the conversation went: "You're ruining your life with alcohol." "Mother, I had a sip once and a drink now – six weeks later." "You're pouring your whole career down the toilet." The result? I started writing things like: "The stage was slippery. The hotel is nice. My pointe shoes are holding up well." Mother's response? "I give up! Just tell me about your whole life again, and I promise not to worry – too much." I should mention that, while I wrote home about once a week, I received a letter from my mother in every one of the 110 cities on that tour. Only much later did I realize how much love that took.

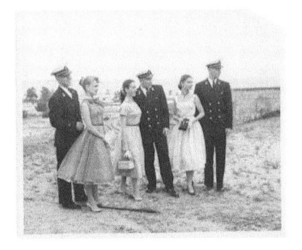

Fort San Carlos Naval Air Station, Pensacola FLA - Roland Gregory, Dorothy Daniels, Me, Irving Jones, Yvonne Craig, Ray Sorenson

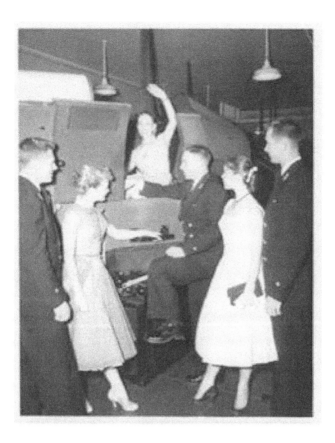

NAAS Corry Field, Pensacola FLA, I wave goodbye to Roland Gregory, Dorothy Daniels, Irving Jones, Yvonne Craig and Ray Sorenson prior to a "flight" in Link Trainer

At Easter that first year, we had a week with no performances scheduled, so my roommates, Bobbie (Yvonne Craig) and Dottie (Dorothy Daniels), flew to Pensacola, Florida (Dottie's hometown) to rest and swim and generally have a good time. My folks were not thrilled. They'd expected me to come home. When the local newspapers heard that there were three dancers from the Ballet Russe in town, they wanted to do some publicity. It was arranged that we would tour the naval air base. Three good-looking young navy men were our assigned escorts, and they took us through "A Day in the Life'. We ate in the mess hall, rode on a ship, and had the opportunity to fly a 'sim.' I was the only girl brave enough to do that. Boy does being weightless make you dizzy! The young men were very nice, and we had a really good time.

We three intrepid, or naive, when you come to think of it, teenagers had decided we could save money on the tour by being a threesome instead of a twosome and by staying at cheaper hotels than everyone else. I don't know why, but the company let us make our own reservations. That worked for a short while, but the places where we stayed were either substandard or in bad parts

of town. The older boys worried about us and took turns walking us to our hotels after every night's performance. Let me explain why we did this. Our salary, before taxes, was $90 a week. After taxes, about $80. Out of that, we had to pay for hotels, food, and everything else except the bus. I used to put $10 into my wallet every morning, and if anything was left at the end of the day, I'd add to it to make up the $10. We got paid in cash every Friday. The big problem was that we spent the first week of every tour living on half pay – our rehearsal salary. Of course, we had to borrow from Mr. Subotin to get through that week, and we spent the whole tour trying to pay him back.

Misha Subotin was the man who sold our souvenir program books in the theater lobby at each performance, shouting, "Get your belly (sic) books! Get your belly (ballet) books!" He looked like Santa Claus, but I once joked that he probably owned half the company. Mme. Pourmel, our wardrobe mistress, demanded, "Who said that?" Everyone pointed at me, and she said quietly, "A smart little girl, that one." It turned out that Subotin was Mr. Denham's best friend and probably DID own half the company!

The Bus and Me

We traveled on two buses, one for the dancers and one for the orchestra, with one large truck for the scenery and costumes on which the stagehands rode. Each dancer carried a small dance bag onto the bus. That bag contained pointe shoes that needed cleaning and new ribbons, books to read

(or, in my case, to study), crossword puzzles, and a purse. A 24-inch suitcase was placed in the luggage compartment under the bus, and a 26-inch suitcase was carried on the truck and delivered to us once a week so that we could change our clothes once in a while. Also on the truck was a theater case that contained the rest of our pointe shoes, ballet slippers, practice clothes, make-up cases, and place settings.

Place settings included a place mat, all the boxes for make-up that didn't fit into our fishing tackle boxes/make-up cases; 'happy-happies' (gifts – mostly tiny animals – that we gave each other when we did special roles); framed photos, etc. We each chose a color (mine was baby blue) and matched everything to that, including the placemat, our theater robe and slippers, and the handles of our brushes and eyebrow pencils, as well as the tops of all the boxes, which we painted ourselves. The theater cases were generally dropped in a pile in the middle of the dressing room floor every night – except for mine.

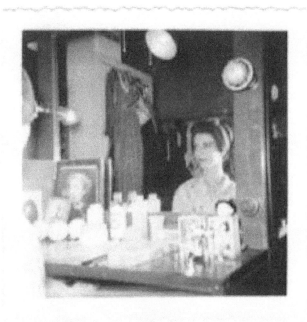

Me and my dressing table (note the baseballs)

Mine was delivered by the stage crew to my designated place. Why? Probably because of the baseballs. I had three autographed balls, signed to me by the then Washington Senators, the Detroit Tigers and the Boston Red Sox. I lined them up (NOT painted baby blue) on my placemat every night. The stagehands evidently thought I was 'different.'

I had read somewhere about the Empress Hotel in Canada, that was like a chateau and was very elegant. So, we three decided to stay there when we got to Victoria, British Columbia. The company had traveled by ferry from Seattle, and at the docks, everyone was rushing to fetch their bags and get taxis to their hotels. Everyone except us. The Empress had sent a limousine and their driver was taking care of everything for us. You can imagine the looks on the faces of the other company members, even Miss Novak and Mr. Denham, as we drove past them, waving like Queen Elizabeth. It was well worth the extra money: the rooms and the lobby WERE elegant, and we had tea and crumpets in the afternoon. It was my first taste of the rich life, and I loved every minute of it, but we had to scrimp and save for the next few weeks in order to pay for it.

When the tour was over, we had three weeks to recuperate, enough time to apply for unemployment insurance but not enough time to collect that first check before we were due back in New York for rehearsals to learn new repertoire, Michel Fokine's Prince Igor and Vaslav Nijinsky's Afternoon of a Faun, both ballets from the Diaghilev company. We danced them in the original costumes – dusty and smelly, as you can imagine. We also had lost some dancers and had to replace them in all of the ballets. One of the girls who had left (remember my 'date's' hidden girlfriend?) had been gaining weight during the last tour. We later learned that she was pregnant – and unmarried. Although we had suspected what was going on, we never said anything. After all, we were a family.

This was an unusual tour because it was summer. We traveled by plane, stayed at least a week in each city and performed in outdoor theaters.

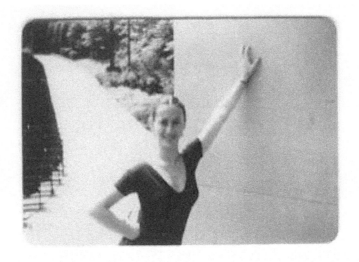

At Carter Barron Amphitheater, Washington DC

Our first stop was Washington, D.C., at the Woodner Hotel and Carter Barron Amphitheatre. I met a woman in the hotel lobby who, when she found out how much I love baseball, promised to introduce me to the teams that stayed at the hotel, and she did! I got to meet the Washington Senators, the Detroit Tigers, and my favorite Boston Red Sox, including the legendary Ted Williams, who shook my hand, the hand that I didn't want to wash for days. He was so attractive that, when he entered the hotel, the molecules in the lobby changed and every woman there straightened up.

Washington in July is hot, hot, hot and humid, humid, humid. We rehearsed onstage in the open-air theater the first afternoon but, after a few cases of heatstroke, we retired to the hotel to rehearse in the ballroom. It rained one night, and we had to delay the performance so that the stagehands could mop up the water from the stage, but it was still so slippery that Mr. Franklin had us take off our pointe shoes for Les Sylphides and told us we were to 'mark' (not dance fully) everything in the ballet. I decided I'd rather go down dancing full out than by tiptoeing around, and miraculously, I didn't fall.

Toward the end of the week, there was a man who looked really familiar standing in the wings on my side of the stage. It was Danny Kaye! He was scheduled to perform there the following week and wanted to check out the venue. In The Mikado I had to stand in parallel position with my arms folded for quite a while, occasionally jumping to one side or the other. Danny Kaye stood in my wing and started, quietly, to do one of his hilarious 'patter' routines. I couldn't help it; I got the giggles and laughed so hard that when I jumped, I fell to my knees and had to crawl offstage. While I struggled to control myself, Danny apologized for breaking me up. He had, however, done it on purpose and said he'd make sure I didn't get into any trouble because of it. After the performance, he asked for my name, and when I told him I was named after his daughter (my middle name is Deena), he gave me a big hug.

During that season, the great Mia Slavenska was our ballerina, Miss Tallchief having returned to the New York City Ballet. Slavenska was a hoot: she would color her hair to match the ballet she was dancing – red for the Don Quixote pas de deux and silver for Black Swan. She would come onstage early, light a cigarette, step onto pointe in an arabesque, penché and stay there. Forever! Her technique was phenomenal, and she was very glamorous. She was a big draw in Los Angeles, where she'd made her home, and she had danced in films, too. Unfortunately, we didn't get to know her very well because she was with us for such a short time.

After Washington we flew off to California (how I loved it there!) for a week at the Greek Theater and another at the Hollywood Bowl. They were distinguished by the number of movie stars who came to performances and were invited to meet us backstage. I especially remember Greer Garson attending several times. She was so lovely, and she really enjoyed the ballet.

Since we had no rehearsals, some of us dashed off to take classes with Michel Panaieff, a former Ballet Russe dancer. His classes were full of 'gypsies' (movie dancers) and muscle beach guys who were there to meet girls – or maybe boys. His classes reminded me of Mr. Vilzak's – they were fun, full of positive energy and friendly competition.

The sun was always shining, and the weather was warm. Those who were old enough rented cars and drove along the coast, dipped their toes into the frigid waters off Santa Monica, and spent their days looking for movie stars. It was lovely!

Back to New York, another few days off, and we began to rehearse for the next tour. This time we only had three weeks to prepare the whole repertoire, including a new, for us, production of Giselle. We also had to slot in new dancers to replace the ones who had left or hadn't been hired back and got to meet our new stars, Alicia Alonso and Igor Youskevitch. He took a particular liking to me, putting his arms around me and giving me a hug whenever I was in his vicinity. I was thrilled until Meredith Baylis said to me, "Look around you, kid. Who else has a figure like yours?" It's true – I wasn't flat-chested like the other girls. I tried to avoid him after that.

Remember the Agnes de Mille story from my childhood? Well, here's its follow-up. During this rehearsal period, I convinced nine of my fellow dancers to audition at an open call for a new Agnes de Mille show – just for the fun of it. There were about two hundred girls there, crowded into a dressing room below the stage of a Broadway theater, trying to change and warm up. As it happened, the ten of us from the company were all placed in the same group. We were tall and short, blondes, brunettes and redheads, slender and voluptuous – a real cross section of America. When it was our turn, we entered from stage left in a straight line, stopped and turned to face the audience. De Mille's disembodied voice rang out, "Make a quarter turn to your right." We did so. "Thank you." We exited stage right without having gotten to speak or to dance a single step! As I approached the wing, she said, "You. The last girl. Turn around." When I did, she snapped, "I thought so!" Ten years! Talk about a good memory!

Alonso and Youskevitch were lovers. Unlike Miss Tallchief, who rode on the bus with us every day, taught us class, and endured the same rigors of touring as we did, Youskevitch and Alonso

36

often flew from one city to the next, arrived late at the theater, and we never saw them warm up. In fact, if Igor got applause on his entrance in <u>Swan Lake,</u> Alicia could be heard to say, "It's a good audience. I'd better warm up." She'd then proceed to do lots of very fast échappés to get her feet ready. We used to joke that before the 'big' cities (Chicago, Boston, San Francisco, Los Angeles), she would use her performance of the <u>Black Swan Pas de Deux</u> as a warm-up for a long barre that she did afterward to get herself into better shape.

When we were in the middle of a series of one-night stands, Alicia and Igor occasionally took a break from the tour. She went home to Cuba and came back slim and in wonderful shape. They told us her husband really worked her hard there. Miss Tallchief may not have been as talented as Alonso, but to me, she was the one who embodied the work ethic of a 'real' ballerina.

The second tour closely followed the same itinerary as the first: from fall through winter across the north of the country (what were Columbia Artists, our booking agents, thinking?); February in California (my mother sent a suitcase full of spring clothes, and I sent one home full of my winter wear); and spring across the south. We also zigzagged up and down, driving as much as 400 miles every day.

We woke up at 6:30 a.m.; packed and ate breakfast in the hotel, if possible (it was the only meal we could be sure of getting all day, and I ate a big one); boarded the bus at 8; had a 10-minute 'rest stop' at 10; had lunch at a diner somewhere on the road at noon and another 'rest stop' at 3; arrived between 4 and 6; checked into the hotel; grabbed a bite to eat or ran off to a grocery store; rushed to the theater; did make-up, a barre and performance; tried to get some dinner (not easy unless we cajoled the bus driver into taking us to a nearby truck stop); rode back to the hotel to wash our tights and pointe shoe ribbons; cleaned our pointe shoes with Carbona carpet cleaner laced with lipstick to keep them pink; and fell into bed around 1:30 a.m. Five hours later, we started all over again. It was wonderful! Not so much if you were older, I guess. They used to say that if you came back for a second tour, you'd probably stay for four, and if you came back for a fifth, you were hooked for life. That was me – hooked for life!

Houston, Texas, was always difficult for us. Sometimes we actually arrived in the morning and went directly to the theater while our stage manager, Lew Smith, checked us into the Rice Hotel. We danced a matinée and a soirée on Saturday and a matinée and a soirée on Sunday. If we were lucky, we stayed overnight again in the hotel. There was usually a rodeo in town at the same time, and we got to meet Dale Evans and Roy Rogers one night when they were playing on the back

half (or the front, from their point of view) of the same stage, at the same time! Dale said she loved the ballet and had wanted to be a dancer.

On this tour, one of the dancers had been having trouble with a blister on her toe. When we looked at it in the dressing room, we realized she had blood poisoning. While Lew Smith called for a doctor, I went to Mr. Franklin and said, "I can do Giaconda's part in <u>Raymonda</u> (the Pas de Trois, a plum role)." He said, "I'm going to cut it because Alan (Howard) is dancing in six of the eight ballets today and doesn't need anything extra on his plate." But I insisted, "I don't need a rehearsal, I know it cold, I'm the understudy, and I deserve a chance at doing it." Freddie finally said, "All right, but if you make even one mistake, you'll never get another solo role as long as I'm here." If that was meant to scare me, it didn't. I danced the whole ballet – WITHOUT a mistake.

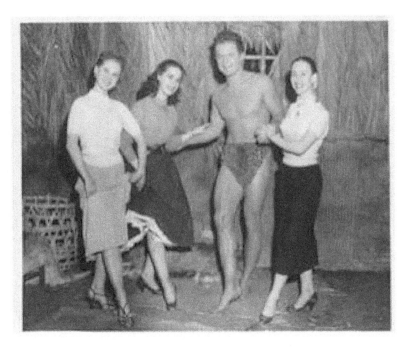

Tarzan movie with Johnnie Sheffield, Dorothy Daniels, Eleanor Dantuono, Me

When we got to Hollywood, three of us took a tour of the movie studios, watched the filming of a jungle movie and got to meet, and be photographed with, Johnny Sheffield, Boy in the Tarzan films. We were surprised at how many mistakes the older cast members made and how short the 'takes' had to be because they couldn't remember their lines. And we kids learned and retained all those ballets!

The next summer, we again did a season at Carter Barron in Washington with a new ballet, Sombreros, choreographed by my mentor, Leon Danielian. I was delighted to be cast in it as one of the eight señoritas. Our conductor, Ivan Boutnikoff, orchestrated several Mexican mariachi melodies for it and the fashion designer, William Cecil, designed the costumes.

Among the new corps de ballet members that year was Raven Wilkinson, a beautiful dancer whom I knew from Mr. Vilzak's classes. Notable about Raven, in addition to her lovely dancing, was the fact that she was Black. Although her skin was actually lighter in color than Alonso's, her facial features resembled those of her black grandmother. She was an interesting, refined young woman, and she and I, a Jew and a Negro, as she was called in those days – remember, this was the late 1950's – soon became good friends. We were the "outsiders": I was the only Jewish girl and she was the only Black. She was, as far as I know, the first dancer of color to be a member of a touring ballet company.

On her first tour, even though we were actually in Little Rock when the Brown v Board of Education events were happening, there were no "incidents." Since we had so many South American dancers in the company, if someone looked at Raven too curiously, we would immediately speak Spanish to her, and the questioning looks were replaced with "Oh, she's a foreigner." I did, however, begin to see things I had never noticed before: separate entrances in the theaters (Whites in the orchestra sections, Blacks in the balconies) and, most ridiculous (to me) outdoor water fountains with separate spigots (the same water ran through them) labeled WHITES ONLY and BLACKS. I wanted to drink from the one labeled BLACKS, just to see what would happen, but my friends begged me not to make trouble.

After that first tour, things got worse for Raven. Maybe one of the stagehands (they all hailed from Gadsden, Alabama, because that's where Lew Smith, our stage manager, lived) or one of the musicians (we carried our own 40 piece orchestra), with no malice aforethought (remember, we were FAMILY), told someone at home about her. Or, maybe someone in one of the hotels figured it out, but it came to a head in Birmingham. When we checked into our hotel, there was a notice at the front desk requiring the whole company to meet onstage. Since that never happened except in unusual circumstances, I asked our new regisseur/ballet master, Michel Katcharoff, (Franklin, exhausted, having finally temporarily left the company) what was going on. He said we had to replace Raven in Giselle that night because the theater manager would not permit her to dance. When I asked him if he'd spoken to Raven and he said "no," I said, "You mean you're just going

to tell her onstage, in front of the whole company?". Sometimes the Russians could be so obtuse. I went to Raven's hotel room and told her what was happening, expecting her to be terribly upset. All she said was, "My parents told me this might happen. I understand. It's all right. Thank you for telling me. I simply won't go to the theater tonight." Just like the dignified young woman she was.

The next year, it was even worse. On our trip from Florida into Alabama, we had to stop at the border to be inspected in case we were carrying fruit across the Florida border. Three huge policemen, complete with guns and whips, got on the bus and said, "We know you got a Nigra on this bus. Get her off – NOW." Big mouth – that's me – said, "You mean you want her to get off the bus and be stranded on the highway all by herself?" "Yup, and be quick about it." Fortunately, Dorothy Daniels' parents were driving her from Pensacola to our next stop, and her father was a prominent doctor, so Dottie got on the bus with us and they let Raven get into the car with Dr. and Mrs. Daniels, who drove her back to their home where she stayed until it was safe to fly her to another performance venue. Things eventually got so bad that the company flew her home for the Southern part of the tour even though, by then, she was a soloist in the company. Both she and Mr. Denham showed great courage for those times, she for sticking it out and he for recognizing her talent and finding ways to make it possible for her to perform.

During the rehearsal period after the summer tour, we prepared a new ballet, La Dame a La Licorne, based on a libretto by Jean Cocteau, with décor and costumes by Cocteau as well, choreography by the German Heinz Rosen and music by Jacques Chailly and Peter Warlock. I was again stunned and disappointed not to be cast as one of the six unicorns. We also learned Boris Romanoff's Harlequinade, in which Dottie and I were given really juicy parts.

"Harlequinade"

We were cast as Blackamoors, had a little trio with Eugene (sigh), and spent the rest of the ballet improvising fun things sitting on the apron on either side of the very front of the stage. Mr. Romanoff liked what I was doing and kept telling me not to be afraid to "do more, more, more." I loved working with him.

The ballet starred Alonso and Youskevitch as Columbine and Harlequin. He was getting older and was no longer at the top of his form; so, when Dottie and I started to get laughs throughout the ballet and applause on the bows that nearly matched that of his and Alonso's, he demanded that we cut down on what we were doing. Remembering what Mr. Romanoff had told me, I refused. Then it began to get ugly. Alonso had no problem with us, but as we were bowing in the front line, we were to hold hands, Dottie with Alonso and Youskevitch with me – and he refused to take my hand! That meant that I had a solo bow, separate from the other principals. Maybe he thought I'd be embarrassed. Wrong! I made improvised bows every night, getting more and more laughs, until

Alonso found out what was going on. I don't know what she said to him, but on the next night, and from then on, Youskevitch held my hand on the bows.

He wasn't done, though. Unfortunately, Mr. Romanoff died in New York while we were on tour. Youskevitch left to attend the funeral and when he came back, while several of us were still grieving, he called me aside and said, "On his deathbed, Mr. Romanoff said to me, 'Tell those little girls to do less, much less. They are doing too much.'" I was totally disgusted and lost all respect for a man who had been one of my ballet heroes. The very idea: Mr. Romanoff hadn't even seen a performance in months!

Licorne taught me a lesson that has stayed with me for the rest of my life. As it happened, the girl that I was understudying was injured just before our Chicago season, and I was 'on' - with no rehearsals, as usual. After the first performance, much to our surprise, Mr. Rosen appeared backstage. We hadn't even known he was in the United States, let alone in Chicago. He thanked us all for dancing so well and then asked who was dancing in Kiki's (Irene Minor's) place. "Oh-oh, I must have made a mistake," I thought, and I said, "That would be me." Mr. Rosen said, "I never cast anyone with light eyes (mine are green) as a unicorn, because I thought they wouldn't show through the masks (half unicorn heads). But I saw your eyes all the way at the back of the Civic Opera House, and that's a huge theater. I won't make that mistake again." And here I'd been worrying about not being cast because I wasn't good enough! Oh, and glancing around at the Six Little Maids in The Mikado, you guessed it. They also all had brown eyes – to make them look more Japanese? From that time on, I never worried about casting. I just figured there was some silly reason for people's decisions. Not my problem, but theirs.

During that rehearsal period, I had my first bout with pharyngitis. I woke up one morning with a throat so sore and closed that I couldn't swallow, and my legs so sore I could hardly walk. My dear Dr. Fleischer was so worried that he came over to the apartment that I was sharing with Meredith Baylis. It was polio epidemic time, and I guess he thought that's what I had. He told Meredith to make me a 'hot toddy' every few hours and to keep me in bed. The drink was enough to do that. It tasted awful. After two or three days in bed I felt well enough to go to rehearsal, although I was still weak from not eating.

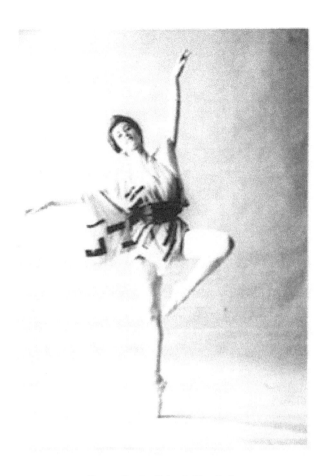

Peep-Bo in "the Mikado"

I got there in time for rehearsal of <u>The Mikado</u> and, much to my surprise, Freddie asked me to dance Peep-Bo, one of the Three Little Maids. I'd skipped right over the Six Little Maids into a ballerina role that Gertrude Tyven had originated. Freddie said to try it and see how much I knew and he'd teach me the rest. We ran the first long dance, a complicated trio and, when we finished, he and Rachel Chapman, our very knowledgeable and hard-to-please pianist, stood up and applauded for me. So did all the members of the company. I was so shaky I didn't realize why until I heard him say, "I've never seen anything quite like that before. Not a single mistake in such a tricky dance, and I don't have to teach you anything." Rachel told me later that he said he wished he had a whole company like me – it would make his job so much easier, even if I was a pain in the neck sometimes.

Also, during that rehearsal period, the dancers initiated a class action suit against the company to recover the salary that we had been cheated out of. The company's Executive Secretary was allowed to choose who would represent the dancers. She chose me! The other dancers were not at all happy with her choice. I guess she (and they) figured that, being so young (and naive?), I would

43

be rattled by Mr. Denham's high-priced lawyer, the well-known Aaron Frosch, and would lose the case for the dancers. That almost happened, but… When I agreed that I had, in fact, signed the document that I was shown in the courtroom every week of every year, all seemed lost. But I explained to the judge that we couldn't get paid without signing it and that all I had ever seen of it was a space for me to write my name. When I asked to look at it again, I simply folded it along the already worn folds. Indeed, all that showed was my name – not the several rows of numbers justifying the deductions the company had illegally taken. The judge who, truth be told, probably felt a little sorry for this young girl going up against a big company, smiled at me and decided in the dancers' favor, and I got a huge 'hand' from all the dancers sitting in the courtroom.

On the last day of rehearsals, we finished up with <u>Sombreros</u>. Miss Borowska, the lead in the ballet, wasn't there because her leg was bothering her – nothing to worry about because things like that happened all the time. As we were getting dressed, the telephone rang in the office and we heard Mr. Danielian say, "Really? That's too bad. You just take care and get well and don't worry about us. We'll figure it out." Then he called into the girls' dressing room, "Raven, honey? Tomorrow night you're going to do Chellie's place in <u>Sombreros,</u> okay?" Now I'm standing there thinking, "What am I, chopped liver? Why am I not going to be dancing?" Then I thought I heard Leon say, "Chellie, sweetie, you'll do Irina's part." That was the LEAD! I threw a towel around myself and popped out of the dressing room in a panic. "But, Mr. Danielian, I don't know it at all. I've never been able to learn it because I'm either dancing at the same time or facing away from her." He said, "Don't worry, I'll be at the theater tomorrow between performances to work with you." A quick hug, and he was gone. So was I, home to call my parents with the exciting news and to finish packing for the tour.

"Sombreros"

Sunday, the bus took us to Perth Amboy, NJ for the start of the tour, matinée and evening performances: <u>Les Sylphides, The Mikado, Le Beau Danube</u> in the afternoon; <u>Swan Lake,</u> the Bluebird Pas de Deux, <u>Sombreros</u> and <u>Gaité Parisienne</u> at night. I was to dance six of the seven ballets that day. My parents dove down from Boston, carrying a large steak packed in dry ice (my father owned a delicatessen), which Dad took to a nearby restaurant and cooked for me to eat between performances. My fellow dancers gave me all sorts of 'happy-happies' including a jar of honey from Perry Brunson which he insisted I eat to give me energy. The matinée went well, after which I rested in my dressing room, eating steak and honey, waiting for Mr. Danielian.

At last, the call came over the loudspeaker, "Miss Zide and all the men in <u>Sombreros</u> to the stage, please." (My heart still pounds as I write this – I was <u>so</u> scared!) When we got there, Leon asked the boys to throw their sombreros onto the stage in the places where they would be during my solo, so that I'd know where they'd be – my bad eyesight again. Then he thanked them, kissed me on the cheek, wished me good luck – and LEFT! I stood there frozen until Perry led me to my dressing room, where I got ready to be one of the cygnets in <u>Swan Lake</u>. While we were standing onstage during the big pas de deux, tears began to run down my cheeks.

Meredith Baylis whispered, "What the h--- is the matter with you?"

"In a half hour I'm going to be on stage trying to dance <u>Sombreros</u>, and I don't know a single step!"

"This is a fine time to be thinking about that!"

Thank heavens she wasn't sympathetic because, if she had been, I probably would have collapsed in a puddle of self-pity.

Mme. Pourmel helped me into Irina's costume and sent me onstage. The way the first movement was constructed, the eight girls faced each other in twos, each couple dancing steps different from the others. Unfortunately, I hadn't been paired with Irina, so, I had no idea what she did. God bless Sally Seven who was Irina's opposite. She said to me, knowing that I wouldn't be able to see her across stage, "Just do whatever you want, Chellie, and I'll follow you." That was fine for the opening, but there were two solos, a pas de deux and other bits and pieces to do on my own and with my partner, Deni Lamont, with whom I'd never danced.

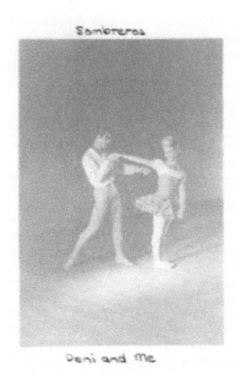

Me and Deni Lamont in "Sombreros"

The second movement was the long pas de deux that was danced while all the other couples, stretching colorful serapes between them, faced away from the center of the stage (in a wide semi-

circle) where the pas de deux was taking place. So, in neither of those two movements had I ever been able to see what Irina was doing. Deni 'talked' me through the whole thing. The third movement was okay: we all danced the same steps in a circle, except for a brief solo for each of the principals. The only problem there would be my being able to find Deni in the outer circle (girls on the inside) – my eyes again.

The ballet began in silhouette and, as I stood in the opening pose waiting for the curtain to rise, my knees knocking in terror, I suddenly thought, "Wait a minute!! They're lucky that I'm brave enough to do this! What can they expect of me? I'm just a kid, a corps de ballet girl, doing my first ballerina role – with no rehearsal! I'm going to go out there and have a good time." And that's just what I did! Mr. Denham was there and he had me presented with flowers onstage during the bows. It was all very exciting. When Irina finally got back, I told her how glad I was that now I'd be able to learn the real choreography – I'd been improvising at every performance – but she said that Leon wanted her to learn my version. He liked it better!

For the next tour, Mr. Denham cast me as the Page in Ruthanna Boris's Cirque de Deux, which I danced with either Deni or Miss Novak's brother, Edmund, who, with his wife Irra, had come from Poland to join the company that season.

Miss Novak also choreographed a beautiful ballet, Variations Classiques, and she made me second cast of the second ballerina role, to be danced by Gertrude Tyven. We didn't know it at the time, but Gerty, who had married Eugene ('my' Eugene) in the off-season, was ill. She missed part of the tour because she had surgery to remove a cancerous breast, and we worked hard to replace her, so I got to dance the new ballet quite a bit, as well as one hilarious performance of the Flower Girl in Gaité Parisienne. I absolutely didn't know it at all, but I made a good stab at it.

The tour concluded with a season at the old Metropolitan Opera House in New York, the first time the Ballet Russe had played there in seven years. We had played at the Brooklyn Academy of Music, but this was The Met. More good news: Mme. Danilova was coming back to dance two of her signature pieces – Gaité Parisienne and Le Beau Danube. To top it all off, the opening night was my nineteenth birthday. My Mom made arrangements to travel to New York for several performances and, as a surprise, to celebrate my birthday in a big way.

47

"Variations Classiques"

On the opening night, she sat next to Hermione Gingold, the film star, and her entourage of adoring young men and heard Hermione say, "Can you believe this woman, who is older than me, is going to dance tonight? This should be interesting." The performance began with <u>Giselle</u> starring Alonso and Youskevitch. When that was over, Mme. D and Freddie came onstage to warm up a bit. She was very nervous. After all, she hadn't danced in New York in years and, truth to tell, her best dancing years were behind her. In fact, in rehearsals, we were quite concerned that she might tarnish her image by doing this; her technique was pretty shot. She said to Freddie, "How can I follow that? They were so wonderful!" Smart as ever, Freddie said, "But Choura, we're not following them; we're following Nina Novak and Alan Howard, who were about to dance the <u>Black Swan Pas de Deux</u> and who probably wouldn't have been doing so except for Nina's close relationship with Mr. Denham.

When Mme. D made her first appearance in <u>Gaité</u> that night, the audience applauded and applauded. We had to stop the performance: we couldn't hear the music! They loved her, as they

always had. With tears running down her cheeks, she started to dance and it was magic. She was a young, gay Parisian Glove Seller and Franklin was her ardent young lover. I felt so lucky to be sharing the stage with them. There were curtain calls galore, and I found a way to squeeze in between the proscenium arch and the front curtain so that I could watch them all. I heard later that Mame. Pourmel was frantically trying to find the twelfth can-can costume: I was still wearing it! By the way, when <u>Gaité</u> was over, Miss Gingold stood and cheered with all the rest. After the performance came my surprise: Mother had made reservations at The Russian Tea Room, the 'in' restaurant for post-ballet suppers. She and I and some of my friends had dinner and then the waiter brought out a huge birthday cake, which I shared with others dining in the restaurant. What a glorious night!

Dorothy Daniels, Eugene Slavin, Me in "Harlequinade"

During that season, Ed Sullivan came to see us perform and fell in love with me in <u>Harlequinade</u>. He said he laughed and cried at my antics and he asked Mr. Denham if Eugene, Dottie and I could do our little pas de trois on his show. Mr. Denham said that wouldn't be representative enough of the company, but he would let us do the czardas from <u>Raymonda</u>. Dottie and I were no longer dancing that, but he put us back in along with other budding soloists. The dancers who usually made up the cast were furious because we were going to be on TV and because we were getting paid a lot: $150! Also on that night's show were Johnny Ray (singer), James Melton (singer), Sugar Ray Robinson (boxer), Gene Fullmer (boxer) and 10-year-old Bobby

Strom, who'd just won over $200,000 on <u>The $64,000 Question</u>. Of all the people on the show, the only one who could communicate with little Bobby was Fullmer, the least likely from his appearance: he looked like the prototypical boxing pug. The two of them spent most of the program backstage doing math problems on a blackboard.

Before the next tour, I made the discovery that would change my life. As I walked out of the studio after finishing class with Mme. Pereyaslavec at Ballet Theatre School, I saw Erik Bruhn walk in; so, I turned around and followed him. I had no idea who was teaching the class, but if Erik was taking it, so was I! A very short, very young man was teaching and saying things I really needed to hear. I was, until that time, a purely instinctual dancer rather than a calculated one: I had my 'on' days and my 'off' ones. This remarkable teacher seemed to think that every day could be an 'on' day, and his corrections were making that possible. At first he placed me in the last line of the last group, but he kept moving me up until, by the end of class, I was right in front of him. The class was full of dancers from American Ballet Theatre and New York City Ballet, and the atmosphere was electric. That teacher was Robert Joffrey.

Robert Joffrey

Mr. Joffrey (or Bob, as everyone called him) taught twice a week at Ballet Theatre School. After three weeks of his wonderful classes, I asked him if he taught anywhere else – I wanted MORE.

"I have my own school."

"Where is it?"

"Come with me. I'm going there now."

We ducked into the nearest subway and rode to Greenwich Village, where Bob's studio was across the street from an infamous women's prison and where I started to study with him in earnest. Soon I convinced some of my friends to come, too, and classes got more crowded and even more electric.

Meanwhile, I hadn't yet signed my contract for the next Ballet Russe tour. I sensed that Bob really liked me, and I hoped that would translate into an offer to join his two-year-old company, the Robert Joffrey Ballet. Finally, Doris Luhrs called me from the Ballet Russe and said, "Rehearsals start Monday, and I need your contract today." Bob hadn't said anything, so I signed the contract, forged my mother's signature as well (I wasn't legally old enough to sign such a document), and delivered it to the Ballet Russe office. Then I went down to the Village for class. Naturally, that was the day Bob decided to talk to me.

"Have you signed your contract yet?"

"I just turned it in an hour ago."

"Do you think they will release you? I want to offer you a position in my company. You'll be dancing the pas de deux in Die Fledermaus with the New York City Opera and will be one of my soloists after that."

My dream had come true, but a little late. This was to become typical of my life with Bob Joffrey.

The next few days were a whirlwind of activity. I went to see Mr. Denham, who simply couldn't believe that I would want to leave the great Ballet Russe de Monte Carlo for this little company that traveled in a station wagon! I couldn't convince him that I no longer wanted to be a teenage prodigy. I wanted to be a real ballerina, and Robert Joffrey was the one teacher who could help me realize that dream. Bob had a friend who knew David Libidins, the Ballet Russe's booking agent, and he tried. My mother called. All to no avail. I was stuck (and I didn't dare admit to the forgery!) So, to rehearsal I went.

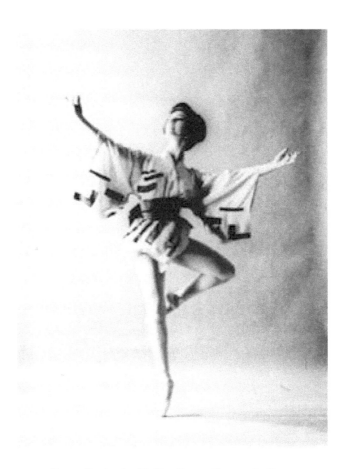

Peep-Bo in the Ballet Russe Souvenir Program

We had new photos taken for the souvenir program books, and five of us – including me – were not in the group shot. When the program came out, I had a solo picture in my Peep-Bo costume. I was now officially a soloist! It should have made me happy, but I missed Bob's classes and wasn't looking forward to a whole tour doing only my own barre and with no music for company class every night. The only new ballet was another by Leon Danielian, <u>Mazurka</u>, and I was one of only five girls in it. The tour was to be shorter – the company was running out of money – and the roster of principal dancers was much smaller than before. I guessed that was the reason for all the promotions: it was much cheaper to pay us only our seniority increases and hire new corps dancers than it would have been to hire new soloists. In a strange way, it meant less dancing for me than before since I was no longer doing corps de ballet work. I even had some 'free nights' and would borrow Irina Borowska's fur coat to sit in the theater as a member of the audience!

We rehearsed <u>Mazurka</u> on the tour, everywhere we could: on stage, in theater lobbies, in hotel ballrooms, in local dancing schools. In Lubbock, TX, 'it' happened. My name being Zide; I was always the last to be checked into the hotel. We were rehearsing that day in the hotel ballroom and

I got there, in practice clothes and pointe shoes, later than the others. I didn't notice that, because the floor was waxed, everyone else was in bare feet. On my entrance, I slipped, fell and hurt my knee but, as usual, I soldiered on. The knee got worse as the tour went on, and I was now dancing in real pain and having to make choreographic adjustments in order to continue. To top it all off, one of the other girls sprained her ankle, and I was asked to dance her corps parts as well as my solos. I knew I should see a doctor, but decided to wait until Los Angeles, where one of the girls, who lived there, could contact her orthopedist for me.

By that time, Yvette Chauviré, the great French ballerina, and George Zoritch, a premier danseur, had joined the company. She was a special dancer noted for her Giselle, Dying Swan, and Grand Pas Classique. I learned so much just from watching her. She didn't speak much English, but I wasn't afraid to use my two years of high school French, so, we communicated quite well. When we got to Los Angeles, my solo dressing room was on the top floor and that climbing, along with all I was dancing, was awful for my knee. I even did my fouettés in Coppélia to the left, my 'bad side,' to get the weight off my left leg. Chauviré liked me and took pity on me and one night, after I had done my barre, she pulled me into her first floor dressing room and told me I was to dress with her from then on. She had even gone all the way upstairs, brought all my things down, and set them up for me. Can you imagine such kindness from a world-famous ballerina today?

As I limped offstage one night, I heard Katcharoff say flippantly to one of the corps dancers,

"I wonder how much longer she's going to be able to do this?"

"That's it, Misha. That was the last performance. I'm going home."

Mr. Denham had been saying that my leg would get better as had the other girl's sprained ankle, but the orthopedic doctor said mine was a torn meniscus (cartilage) and would need surgery. I didn't want to be operated on in Los Angeles. I wanted to GO HOME! After several days, Mr. Denham finally got me the cheapest possible plane ticket to Boston: it was a night flight of eight hours with absolutely no food - and that in the days when they served food on flights. All I got was one cup of coffee and, when I asked for a refill, I was told I couldn't have one – only one to a customer!

My dad had found a good orthopedic surgeon, Dr. Ober, in Boston. His examination showed that the top of my fibula was broken – torn off, in fact. I'd been dancing on a broken leg for two weeks. No wonder it hurt! He bandaged it, splinted it and told me to rest – impossible for me. I

cried on the night I had been scheduled for three ballerina roles and then got to work. Dad found a box of records (vinyl in those days) in a record shop that included a barre done lying on the floor devised by a great Russian teacher named Boris Kniaseff. I started to do it, at least the ones that didn't hurt my knee.

Dick Fishman, one of my Brookline High School friends, invited me to Skimmer Day at the University of Pennsylvania, and I went and did something totally 'normal' for the first time in my life – I went on a date! I think I enjoyed it so much because I knew it wouldn't happen again – I was going to dance as soon as possible. Here I was, twenty years old, after four years with the "scandalous" Ballet Russe de Monte Carlo, and still a virgin! The Skimmer Day weekend was the first real date I'd ever had. I thought it was because I was so homely. Years later, Perry Brunson told me the real reason. When he got into the company, the older South American men sat all the new straight guys down, pointed to each of us young girls and kept saying "Jail bait! Jail bait! Jail bait! Hands off them!" In those days, men couldn't take young girls across state lines for illicit purposes, and we crossed state lines nearly every day.

My friend Walda and I drove to see a performance that the Joffrey Ballet was presenting nearby, and we were impressed. Here was a tiny company, with simple costumes and no scenery, whose main emphasis was on dancing – good dancing. Yes, that was what I wanted at that stage of my career. I was sure I was making the right choice. Of course, I had written Mr. Denham all the details of my injury and soon received a letter from him. Much to my surprise, it contained a check – but not for my salary. No, it was my three weeks severance pay: I had been dismissed! That was going to make my transition to the Joffrey just that much easier.

When I got back to New York, Mr. Denham asked me to come to his office. Miss Novak was there with him, and I suspect she had initiated the meeting. He asked me how I was, told me how valuable I was to the company and said he hoped I was coming back.

"But you fired me."

"My lawyers said it was the best thing to do financially."

"Do you understand how much that hurt, after all I've done for the company? Why should I come back?"

"You're a Soloist now and I have many roles planned for you."

"What roles?"

54

"Well, to start with, we're reviving <u>Ballet Imperial</u> and you'll dance one of the demi-soloists."

"Excuse me. I could have done that three years ago. I should be doing the second ballerina. Mr. Denham, I don't think you've ever really understood what I'm capable of dancing." Then Miss Novak said, "I told you she's not stupid, Sergei." She's very smart. Let me talk to her."

Nina went on to list all the reasons I should stay and told me how much she liked my dancing and how she would make sure I had the roles I deserved. I thanked her, told her I would think about it, and left. Ah, the power you have when people offer you something you don't want! Of course, I had no intention of going back. Later that year, when I saw a performance of the company in New Jersey, it was so bad that I cried for what it had once been. The company folded (closed down) two years later. Yes, I definitely made the right decision. Thus ended the Ballet Russe chapter of my life.

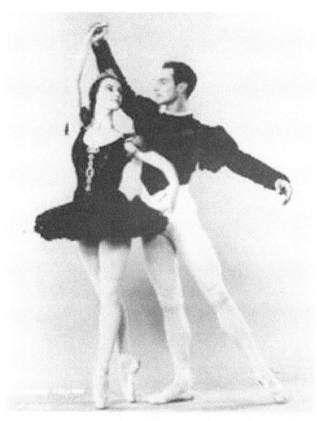

Gerald Arpino and me in Balanchine's "Pas de Dix"

Act Two, Scene One

The Robert Joffrey Ballet

Tension is Misplaced Energy

I've been having real trouble getting started on the Joffrey portion of my book. Why? I guess it's because my feelings for him are so conflicted. On the one hand, he was the best teacher I ever had; I trusted his artistic judgment, I loved him as a person (I even saw myself as Nijinsky to his Diaghilev), and I also loved my roles in the company. On the other hand, he was emotionally abusive and cruel to me; all of the roles I so enjoyed dancing were given to me by outside choreographers – not one by him; he never worked with me the way he did with the other dancers – I kept telling myself it was because I learned so fast he thought he didn't have to; he seemed to like me only for my brain – not my dancing. He didn't treat any of his other dancers the way he treated me. I told myself that when learning from him became outweighed by the way he was treating me, I would leave.

Maybe, in a way, I was his alter ego, the one who could – and did – live the dancing life he wanted. Like him, I am short and have a less-than-ideal dancer's body but, unlike him, I never let that stand in my way. His reality was that he'd probably never dance Albrecht in <u>Giselle</u>, so, why dance at all? Mine was that I was going to dance, no matter where, no matter what, and my body was not going to stop me. Was he perhaps envious of that certainty? Did seeing me in class and performance make his life painful for him in a way?

In July of 2009, I happened to be in New York City and made a visit to the Library of Performing Arts at Lincoln Center. While there, I watched a video of Bob Joffrey teaching a class, and memories came flooding back to me. "Oh, that looks like one of <u>my</u> combinations." And, "Oh, I remember that correction." I had forgotten how much he had influenced me as a dancer and as a teacher but there, flickering on that monitor, was the proof.

My career with the Joffrey Ballet began when I returned to New York after being 'off' for nearly ten months and after weeks of physical therapy with Dr. Hans Kraus, President Kennedy's orthopedic surgeon, whom Bob had recommended to me. After two weeks of intense and painful sessions utilizing ethyl chloride spray and forced bending of my left knee (the one I had broken in the Ballet Russe), I told the nurse that I had no more money and that I couldn't afford to continue the treatments. She asked me to wait while she spoke to Dr. Kraus, and when she came back she said, "The doctor says you are to keep coming until you are well. There will be no further charges." And the dear man treated me, for no charge, until I was ready to dance again.

All that time off had taken its toll. I was only a little bit out of shape (bless the Kniaseff floor barre), but I had gained weight. I began taking three classes a day and, as Bob wanted me to lose ten pounds immediately, I started on a strict diet: only hard-boiled eggs, cottage cheese and water for a very long time.

It was several months before we started rehearsals, but in the meantime, I found two new roommates, both dancers from Boston. Marlene arrived on a Saturday, and on Monday, when I got home from the studio, I found her curled up on her bed, rocking unhappily.

"What's the matter?"

"Do you realize we have no social life?"

From then on, thanks to Marlene, we certainly had a social life! Choreographers and dancers like Michael Bennet and Gus Trikonis, singers like Bobby Zimmerman (I told Marlene she could do better than that – he wasn't very good-looking. It turned out she couldn't. His name is now Bob Dylan!) and jazz musicians like Don Ellis and Gerry Mulligan found their way through our apartment. Gerry Mulligan arrived with a bottle of champagne for the three of us and a bottle of whiskey for himself. He sat down at the desk and wrote poetry for us – I wish I knew what happened to those papers!

Through Marlene, I also met and dated Bill Cosby before he was BILL COSBY. After our first date, I told him not to waste his money on taking me out to dinner again: he made me laugh so hard my stomach hurt and I couldn't eat. After that, we just went to Birdland, a famous jazz club, and enjoyed the music. He sometimes invited me backstage into the Green Room when he was on the Johnny Carson Show and he was, at all times, a real gentleman. It's hard for me to believe what's said about him now.

In September of 1958, we signed our contracts for the fall New York City Opera season. In the first week, Bob choreographed La Traviata, Turandot, Carmen and Die Fledermaus, all the while working around the regular class schedule at the studio. That meant lots of late nights for us, as late as 1:40 a.m. at least once. Many times I didn't even go back to my apartment, but stayed with Françoise Martinet, whose apartment was within easy walking distance of the studio. Françoise and I were told to understudy Diane Consoer in Die Fledermaus, Françoise with Nels Jorgensen and me with Gerald Arpino. Diane and Jonathan Watts weren't going on the tour, so, one of us couples was going to dance the beautiful pas de deux. I don't know whom Bob would have chosen

but, as it happened, Nels hurt his back, so, Gerry and I danced it. Françoise said she was very nervous for us because we hadn't really had enough rehearsals. But, by the end of the first phrase of music, when we finished a long 'finger turn' exactly on the musical climax, she said she relaxed and thought we'd be fine. We were lucky that the orchestra conductor was Seymour Lipkin, a world-renowned pianist, who played for us in rehearsals so that he could learn the right tempi, and they were perfect. Bob was supposed to come and see us but he didn't make it. The chorus singers and Loren Driscoll, who played Prince Orlovsky, liked Gerry and me so much they bought a bouquet of real flowers and substituted them for the prop usually given to the ballerina! That was a lovely thing to do.

In addition to the above-named operas, we also did La Cenerentola, for which Bob choreographed a big ballet to Rossini's Matinées Musicales, another big ballet plus a Marsovienne character dance and a can-can (thank you, Ballet Russe) in The Merry Widow, Rigoletto and Carlisle Floyd's Susannah. In Benjamin Britten's Rape of Lucretia we did no dancing but played at being seductresses. I always got to be in the front in this one because the tenor was so short!

The ballet in La Cenerentola consisted of an enrtada, two pas de deux and a finale. Bob had two couples learn each duet and then he split them among us. I was thrilled to be given mine to my favorite music from the suite, the Waltz. Bob initially seemed pleased with me but grew more sarcastic as time went on. I never figured out why, as I was doing my best to please him. The Merry Widow was an even worse experience. The ballet began with a series of pas de deux, one for each couple. We all sat outside the studio waiting to be called in to rehearse. The other couples, in turn, went in to learn their duets, but Vicente Nebreda and I were never called. Finally, Bob told me that I was to leap onstage in a circle with Vicente chasing me – and leap right off! We also repeated that sequence at the end of the ballet. I was so unhappy to have so little to do. Either I hadn't inspired him to work with me, or he'd forgotten about us, neither of which was very flattering. At the orchestra dress rehearsal, however, the dance historian/critic, Lillian Moore, came backstage, raving to Bob how smart he'd been to make Vicente and me the stars of the show. She thought we were brilliant in our little bits! The next day, Bob took out one of our entrances. He later rechoreographed the whole ballet and gave the two of us more to do.

One day, after rehearsal in New York, we took the bus to Philadelphia to perform Turandot. In addition to the scary, shaky platform on which we did our first dance and the Academy of Music's raked stage, we had something else to worry about: we'd forgotten our fans and Marie Paquet had

forgotten her ballet shoes. Brunilda Ruiz suggested we make our own fans, which we did, giggling all the while. But Marie had to dance barefoot and that couldn't have been much fun on a splintery floor.

Just after the opera season, Michael Maule, a principal dancer with both American Ballet Theatre and the New York City Ballet, called Bob to ask permission for some of us to audition for a chance to dance with the Palm Beach Ballet during the Christmas break. He chose five of us to fly down to Florida to rehearse and perform in The Princess, with choreography by JoAnna Kneeland and a score commissioned from Mario Braggioti. We were housed in what had once been a tuberculosis retreat, right on the ocean, with an enormous kitchen filled with all kinds of food, cooked especially for us, and huge tubs of ice cream just waiting for us with some large spoons. Our first day of rehearsal was a bit of a shock. It seemed that we had been hired – we were members of the Joffrey Ballet, mind you – to be the corps de ballet, standing behind JoAnna's dancing school students. They were on pointe while we danced in ballet shoes. So, the choreography was really easy for us. Class the first day was ridiculous: it started in the center (instead of at the barre) and ended with each of us having to curtsey and thank the teacher. The next day we all did our own barre before class and, that day, I was the only one who continued with the classes – the others did their own warm-up. I've always thought I could learn something from everyone I worked with, and this time it paid off. The girl I was understudying (each 'New York girl' was given an understudy part) got the flu and I was on, in a solo on pointe. JoAnna liked me because I was so cooperative and because I treated her with respect. One dancer, from the New York City Ballet, had also been hired, but she got so fed up with all the amateurish nonsense that she left during rehearsals and flew back to New York.

To explain how amateurish it was, in one of the many dress rehearsals, when the stage manager called "Places!", they immediately turned out all the lights. I ran offstage, tripping over a bench that was part of the scenery, and hit my head on a light boom in the wings, scraping my face. When the lights came up, I heard a gasp – my cheek was bleeding. The good news: I didn't have to wear full make-up for the remaining rehearsals. Everyone else did, even we professionals. The bad news: the E.R. doctor at the hospital said I'd probably have a scar. Here I was, twenty years old, with no boyfriend in sight, and I might have a scarred face for the rest of my life. When I called my mother to tell her what had happened, here was her sympathetic reply: "Don't come home until it's healed. I'm embarrassed to tell my friends you fell again."

One of our boys also had to make a hospital trip because of the unprofessional way things were done. While holding a prop knife; he was waiting in the wings for his next entrance. Someone ran into him. It turned out the knife was real and it had a sharp blade! He wound up in the E.R. with a stab wound in a very bad place. Fortunately, both of us were all right. When we got back to New York, Bob was angry with all of us – we'd gained so much weight from all that good food.

Marlene, Frannie (my other roommate) and I were still living at the Excelsior Hotel on 79th street, across from the Museum of Natural History (what a good deal - $175 per month divided by three for a bedroom, living room, kitchen and dining area, including maid service every day, with clean linens, and no charge for the telephone, as it was the hotel's switchboard). One morning Marlene shook me awake.

"Chells, there's smoke pouring in under the door, and the wall is hot."

"Don't open the door, Marlena."

When I phoned down to the front desk, they said that a man across the hall from us had fallen asleep while smoking and that we were to stay put until the firemen told us what to do. Marlene began rushing around the apartment, trying to decide what to save – that's how I found out she hid money in her socks! - while I stood stark naked in front of the full-length mirror in the bedroom, putting on my eye makeup.

"Aren't you going to get dressed and grab your things, Chells?"

"Marlena, whom are they going to rescue? You and your socks or me and my eye make-up?" Fortunately, everything turned out all right and nothing of ours was lost or damaged.

At this time, I was called to appear before a board of Workmen's Compensation doctors for a final determination of my broken leg case. They decided that I'd permanently lost 1/16 of the mobility in my left knee. That was discouraging, but at least I got a small monetary settlement from them, which was a big help to me, especially since Jaquetta Keith, who presided over the desk at the Joffrey studio, suddenly informed me that I'd have to start paying for classes. With unemployment having been cut and with no income from performing, I simply could not afford my living expenses. In fact, I was already only taking the subway to the studio in the morning and walking home at night – over 80 blocks. Bob's solution was to have me sit at the desk, mostly at night or on Saturdays (after my own classes were finished for the day) in return for free classes. Those are the kind of things that made him so lovable to me.

He also had me teach some of the Adult Beginner classes, where one of my students was Alex Ewing, the son of Lucia Chase (the Director of American Ballet Theatre). He was later the General Manager of the Joffrey Ballet. That's also when I began to write the notes (combinations of steps) for Bob to use when he taught at dance conventions. All that time, people thought they were getting Joffrey classes, but I was actually choreographing them! I enjoyed doing them because it meant he had to work with me to learn what I had written and, sometimes, I got to go to the conventions to demonstrate for him. In our classes at the school, he used me to demonstrate technique, especially pirouettes (turns) and jumps, both large and small, and batterie (beating of the legs). He used wonderful phrases to help us improve. "Tension is misplaced energy" was one of those.

All this time, Erik Bruhn was taking classes at the school. What an inspiration it was to see someone as nearly perfect as he was. I learned so much from watching him and now realize that, along with Bob, he was a great influence on my teaching. How lucky I was that they were both in my life at the same time! Sitting at the desk meant I got to talk to Erik while he was waiting to go out to eat with Bob. That is, I could have been talking to him, but I was absolutely tongue-tied around him, and all I could say was "Mr. Joffrey will be ready in a minute," and "Would you like to look at a magazine while you're waiting?" One day Bob said to me, "Erik thinks you don't like him. He says you never talk to him" What exactly do you say to a god?

In those early days of the company, Bob was still around, in the studio, on the bus, accessible in his office and at parties, especially informal ones. I especially remember one holiday at Françoise's apartment. It was all about crepes. The idea was to take all the change out of your pockets, hold it in your right hand (if you were right-handed) and flip a crepe as you cooked it. If you were successful, you would have money all year. If not, not. Everyone managed it except Bob and me, so we were going to be poor that year. I don't know about him, but it was certainly true for me.

We had a photo call on the stage of the Henry Street Playhouse to begin the publicity for the company's next tour – my first. A group of us were dressed in our 'uniform costumes'(black bodices and colored knee-length skirts) and had a wonderful time as Bob choreographed the poses he wanted us to take. Martha Swope, the famous dance photographer, took the photos and there are two I especially treasure of me being partnered by Bob.

On March 19, I signed my NYCO contract for the spring season, and we began rehearsing the 'American' operas (operas written in English). It was a very exciting season because of our

directors: Delbert Mann for <u>Wuthering Heights</u> and John Houseman for <u>The Devil and Daniel Webster</u>. Working with Houseman was a wonderful experience for me. He directed us as if we were actors in a movie, and he expected us to remember his 'blocking.' We dancers were pretty good at that, but the singing chorus just couldn't get it. He finally had us dancers lead the way in all the crowd scenes and once, after I was the only one who remembered an entrance, he chose me for all the special little 'bits' in the opera; so, I really enjoyed those performances.

When the Bolshoi Ballet played at the old Metropolitan Opera House, Françoise, Gerry and I decided it would be fun to wait on line all day for standing room places. The weather was dreadful, rainy and cold. It was also my birthday; so, after we got our tickets, they bought me dinner at a nearby café.

Lillian Moore saw us in line and brought a New York Times reporter over to talk to us and take photos. You see, Dorothy Kilgallen had just written an insulting column about the Bolshoi, singling out the great ballerina Galina Ulanova for special opprobrium. She'd written that any girl in the back row of a Broadway chorus line could outdance her and that, in fact, she "couldn't dance her way out of a paper bag." Miss Moore wanted the Times reporter to see that America's professional ballet dancers didn't feel the same way as Miss Kilgallen. Marilyn Monroe and Arthur Miller were among the luminaries whom we saw at that wonderful performance.

One of Marlene's friends, Frank Pietri, invited us to the opening night of <u>Destry</u>, a Broadway show he was dancing in. It was our first Broadway opening and we were really excited. Although our seats were at the top of the balcony, we got all dressed up and I joked about what a grand entrance we were going to make that night. I really did make a grand entrance: at intermission as we were descending to the lobby for a drink, I slipped and fell, landing on my rear and, holding on to the handrail, I proceeded to speed down what seemed like thousands of steps, my legs extending straight in front of me, feet pointed and crossed in fifth position. People stared, and Marlene collapsed in laughter. I gather word spread because Frank told Marlene the actors were talking about it backstage. I would have been embarrassed except that I was having too good a time being noticed by everyone.

At that time, Gerry opened a little shop in Greenwich Village, selling odds and ends to raise money for the company. We all helped him set it up, spelled him at the cash register, and sold the merchandise when we had the time. It was just another of the 'fun' things we did as a company/family. It was also one of the reasons why Gerry couldn't take many classes. He was the only dancer I knew who actually improved on tour because that was the only time he got regular classes. The rest of us only hoped to maintain our technique on tour, but his got better and better.

The next project for the company was a pas de trois choreographed by Lillian Moore. The three characters, all famous early American ballet dancers, were Augusta Maywood (Françoise/Bea Tompkins), George Washington Smith (Nels/Gerry) and Mary Ann Lee (Brunie/me). The women's solos were danced with props: Augusta had a scarf and Mary Ann, as Fatima, had finger cymbals. It was a lovely trio, very difficult technically but fun to do. We worked on it for hours and days and were finally ready to show it to an invited audience consisting of Bob, Alex Ewing, Violette Verdy and Erik Bruhn. Brunie decided not to come in that day; so, I had to dance it with both casts. We rehearsed it twice (both casts) and then performed it twice (both casts). Not only was I completely winded and exhausted by the end of the second time, but, as my variation finished on one knee and, as luck would have it, right in front of Erik, who was sitting on the floor at my eye level, by the fourth time, I was so tired and nervous to be dancing for my hero that I couldn't get up! Violette took me aside afterward and said, "You are wonderful in this dance. You must be sure Mr. Joffrey puts it in the repertory." Nice try, but it didn't work. Although we kept rehearsing it for a while, we never did perform Miss Moore's pas de trois.

Me, Vera Volkova, Bob Joffrey, Lillian Moore, Hilda Butsova, reception for Mme. Volkova

The most exciting news for us was that the great Vera Volkova, Vaganova's protegée, was coming to do a teaching residency with us. First, we all, including Bob, spent a day and a night cleaning and scouring the studio from top to bottom, having a great time and laughing the whole while. The reception party for her was very gala, with many of the greats of the dance world in attendance. Mme. Volkova was a lovely lady, warm and humble. She made me feel comfortable with her right away. The company was scheduled to take her first class every day, with guests invited to take the second. I must have looked downhearted at this news, so, Bob made a deal with me: if I agreed to take notes I could watch the second class every day in addition to taking the first. What heaven! I learned so much from her, not just technically but artistically as well. Bob was in heaven, too, wearing a broad smile the entire month she was there. Madame seemed to like me – at least she corrected me a lot. She also had a habit of asking someone to bring her lunch, which she ate in Bob's dressing room, and inviting that person to share the time with her while she ate. When my turn came (we were all on a schedule), she was very complimentary to me and told me she had just the young man to dance with me - in Copenhagen! She expected him to be a great dancer and thought we would be very good together. His name was Niels Kehlet, and he did become a principal dancer of the Royal Danish Ballet.

One day, a group of us, including Mme. Volkova, drove to Jacob's Pillow to meet Marie Rambert, the Founder and Director of Britain's Ballet Rambert who greeted us with a hop, skip and a cartwheel. What an incredibly spry and energetic old lady she was! We were to see Lupe Serrano, a ballerina of American Ballet Theatre, and Erik dance the Black Swan Pas de Deux and Erik's pas de deux Duet. Madame was furious with Lupe for holding her balances beyond what the musical phrasing would allow, and she told her so after the performance. Duet was incredibly difficult, just how much so we were about to discover for ourselves when Erik set it on us.

In the meantime, my worst nightmare had shown up at the studio – a dancer who was my fiercest competitor and who caused terrible feelings of insecurity in me. When I thought Bob might take her into the company, I was insanely jealous and almost ready to go back to the Ballet Russe. The first day of Erik's rehearsal, she grabbed Gerry as a partner. The other couples were paired off, leaving me with nobody. That turned out to be wonderful for me, because I got to dance with Erik. He later placed me with Gerry, but the ballet was never performed by us. None of our men were able to navigate the difficulties of the choreography or the partnering.

Lots of things were going on at the same time. We had a company meeting to introduce four new dancers (not, thank heavens, my nemesis) and to hear plans for the summer and the fall. Bob then left for a week to teach in Texas (he did lots of extra work like that to make money for the company) and hired Alexandra Danilova to teach at the school for him. Her first class was very crowded but, by the end of the week, I was the only company woman still there. She loved the men, and they loved her, but she was, to say the least, a strange 'fit' for the company. We were so used to working correctly, both anatomically and technically, and that was not her way at all. For instance, in that first class she corrected Marie Paquet's fifth position at the barre, wanting her to force her turnout to approximate the 180° Mme wanted. When Marie said that it hurt her knees, Danilova replied, "You professional dancer? I surprise you not know this secret; bend them!" That was Marie's last class and all the other girls left with her. I stayed on because Danilova had been such a great ballerina. I felt I could learn so much about style and how to look like a ballerina just by watching her.

Bob also tried to find outside work for us so that we could earn much-needed extra money. For instance, we did a Revlon commercial for a nail polish called Fire and Ice. We were all supposed to be Spanish dancers and were led by Luis Olivares of the José Greco Spanish dance company. We had a ball doing it because the work, though the hours were long, wasn't hard at all. We

choreographed our own bits and, since I was paired with Vicente Nebreda, the only Spaniard in our company, he and I were in the front most of the time.

The men's and women's dressing rooms at the studio were separated by a partition that didn't quite go all the way up to the ceiling. One day, Vicente called out in Spanish, "Chellie, the new boy is here, and he's a blond – just for you. (Every Jewish girl wants a blond prince!) If you don't want him, I do." Blond Meljuan James De Bolt became my first real love. We were together for several years, even after he left to join NYCB.

Another dressing room highlight: as we girls dragged in after (or between) rehearsals, we would often complain. Françoise Martinet finally had the idea that we should pay for each complaint: five cents for "my feet hurt"; ten cents for "my muscles are sore"; and 25 cents for 'I'm tired." One day, Marie came in, threw a quarter into the middle of the room and said, "My feet hurt, my feet hurt, my feet hurt, my feet hurt, MY FEET HURT!"

There was another adorable young man in classes, and he and I became friends. One day he invited me to his apartment to tell me that he was very excited because Bob had asked him to choreograph a ballet for the company. Dirk Sanders was a Belgian dancer from Roland Petit's French company, and Bob thought that, with his Petit background, he would be a 'natural' to do a ballet for Françoise. We started to work on it right away. There were two leading casts: Françoise with Nels Jorgensen and Gerry, and me with Paul Sutherland and Dick Beatty.

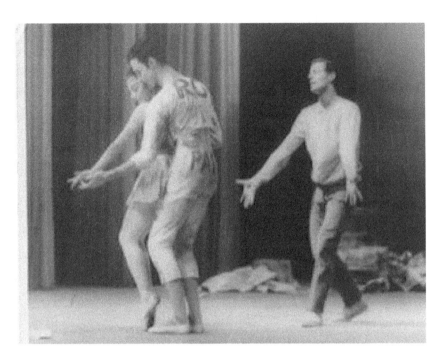

Nels Jorgensen, Me, Gerald Arpino in "Yesterday's Papers"

The ballet was called <u>Yesterday's Papers</u> and was a story about a lonely newsboy (Gerry/Dick) who makes a boy and girl out of discarded newspapers to keep him company. (Nels/Paul, Françoise/me). Unfortunately, the boy and girl fall in love, and the newsboy is even more lonely than before. The music, Bela Bartok's <u>Sonata for Two Pianos and Percussion</u>, was definitely not the oom-pah-pah ballet music of that time, and the choreographic style was also pretty unusual for American ballet. It was also not very popular with the four couples who made up the corps de ballet. In fact, Vicente was heard to exclaim one night as Gerry was wadding newspapers into balls and throwing them angrily at his creations, "My kingdom for a broom!"

Dirk was counting the music by musicians' counts, and they were very complicated. I decided to buy a recording of the music, listen to it at night just before I fell asleep, forget about the counts and just dance freely to the music's accents. Françoise was really struggling, trying to count it Dirk's way. At first, we had equal chances to rehearse the piece, and Dirk seemed equally pleased with us all. One day, however, things changed. My cast hardly ever got to dance, and, when we did, Dirk's criticism was very harsh. The dressing room was awash in tears: Françoise was upset because he gave her so many corrections. I was upset because he gave me almost none. And Marie was upset because she was tired of being an understudy.

Finally, Bob came to watch run-throughs of the ballet. Françoise's was the first cast, so, they did it first. Then it was our turn. Bob didn't say anything, but he didn't look happy. The next day the casting went up on the Board: Gerry, Nels and ME! Françoise was very gracious about it: she said she needed more time to work on it anyway. It certainly meant a lot more work for me with two new men as my partners, but I loved the piece and was thrilled to be dancing it. Later, Dirk's wife Annie told me that he knew pretty early into rehearsals that he wanted me to do it, but Bob would have none of it. That was why Dirk seemed so angry with me: I had to be perfect to show Bob and to prove Dirk right. Nobody's perfect.

The next visitor to the studio was Peggy van Praagh, soloist of Ballet Rambert and the London Ballet and principal dancer of the Sadler's Wells Ballet. She arrived to teach us the Peasant Pas de Deux from Giselle and Antony Tudor's Soirée Musicale. Although Bob continued to insist that choreographers had their own choice of cast, I was beginning to understand that it was not the case. It hadn't been so with Dirk and it wasn't now with Miss van Praagh. She wanted me for the part that had been created on her as the Bolero soloist in Soirée Musicale, but Bob wanted that for Brunie. Peggy van Praagh was a strong lady, however, and she got her way. Since I was such a quick study, she told me to learn all the other parts in Soirée as well. That was lovely because it gave me a chance to dance the romantic Canzonetta with my dear Jamie. She also had both Marie and me learn the Peasant Pas, with me as second cast.

One day, we were informed that Mr. Tudor would be coming to watch us the next day, and Peggy explained what would probably happen. "He'll watch you run the ballet through once and then dismiss everyone except the Tirolese pair. That's the role he danced himself, and he'll claim that I've got it all wrong."

"Soirée Musicale"

That's not exactly how it turned out. He did, indeed, watch one run-through and then let everyone go except for the Bolero! We (it was a trio) danced it through twice and then he sent the other two girls home and kept me alone – for hours! He changed several things, making them more and more difficult until, finally, when he asked me to do it once again, I said, "Mr. Tudor, I'll be glad to do it for you tomorrow, but no more today. My feet are a bloody mess (from landing on pointe in a circle of big leaps)." With a little smile, he thanked me and let me go. Peggy said he'd continued to work with me for so long because he was interested in me. Fortunately he didn't remember the seven-year-old child from his professional class at Ballet Arts or maybe, like Agnes de Mille, he did!

The first, for me, Joffrey Ballet performances took place at the Chautauqua, New York, summer festival. We were accompanied by the Chautauqua Symphony Orchestra, conducted by our own Julius Rudel of the New York City Opera. The repertoire consisted of Brigadoon, in which I played the Fishmonger, and The Bartered Bride, in which I was an acrobat (thank you, Virginia Williams). The Bartered Bride caused one of those accidents my mother always complained about. In our entrance, I was supposed to appear sitting on Vicente's shoulder. In the dress rehearsal, as he lifted me, we didn't notice the low overhang we were directly under and I hit my head so hard that I lost consciousness. We didn't pay as much attention then as we do now to concussions, but that's what

I think happened to me. Somehow I managed to stay on Vicente's shoulder for the entrance and then do the whole dance. Bob's correction for me: "Your dancing was all right, but why were you swaying back and forth when you were supposed to be standing still?"

Chautauqua was a wonderful place in the summer. The train trip up was lovely; the grounds were beautiful, and the very air was permeated with music. Jamie and I would buy sandwiches for lunch, race to the open-air amphitheater to hear rehearsals of heart-stopping pieces then race back for our own rehearsals. He and I were really getting to know each other by then, and I was falling in love with my first real boyfriend.

In addition to the operas, we were also rehearsing Soirée and the Bartok for performance there. Dirk was killing us with hour after hour of work on the Bartok – on pointe. It got so bad that, for the first time in my life, I broke down and cried during one late night rehearsal. Dirk felt awful and immediately let us go. "I'm sorry. I didn't realize how late it was. Get some rest. Go to bed. See you tomorrow."

Dirk's wife, Annie, did a special make-up and hairdo for me for the ballet. It was quite glamorous and mysterious-looking – not at all like the real me, but perfect for the piece. She also wanted to bind my bosom to make it look smaller. "I think NOT!" The performance went splendidly, and even Bob was pleased. He told me, "You made the ballet!" After we finished the season, we took the train back to New York to rehearse for the upcoming tour.

On August 31, 1959, the Robert Joffrey Ballet performed in Boston. Before the performance, Bob called me to demonstrate for him at a convention at the Somerset Hotel. The extra work was obviously too much for me because, at the rehearsal afterward at John Hancock Hall, where we were to perform, I sprained my ankle. Unlike today's football players, we dancers just did our performances, sprained ankles or not. Bob was "tremendously pleased" with Soirée Musicale, while Annie said I was "really outstanding" in the Bartok. The next day I again demonstrated at the Somerset the two variations from the Peasant Pas, and Bob said I did them "beautifully."

Back to New York again for more rehearsals. Francisco Moncion of NYCB arrived to begin his ballet Pastorale, and that led to the first chink in the "family" of the Joffrey Ballet. One of the new girls, Mary Ellen Jackson, was chosen to alternate the leading role with Brunie. In fact, she was scheduled to dance the first several performances. But Brunie was "ours" - she was one of us – and we didn't like her having to compete for a role that so suited her. As for me, I wasn't called at all, which was a disappointment for me. Bob was also rechoreographing his A La Gershwin. I

71

didn't seem to be cast in that at all. Instead, Bob had me rehearse a group of replacement dancers to perform in the fall season of the NYCO since our tour was scheduled to take place at the same time as the opera season.

At the time, I thought he just wasn't inspired to work with me, but maybe he simply trusted me to know and remember the choreography of the operas. In a very short time, I taught them <u>Die Fledermaus, La Traviata, The Merry Widow, Carmen</u> and <u>Turandot</u>. One night I poked my head into the other studio, where Bob was working on the Gershwin.

"I'm done for tonight. May I go home?"

"Oh, no. Why don't you come in and I'll turn this duet into a trio."

Not very complimentary, but at least I would be doing something other than merely moving the scenery around the stage and singing "S'Wonderful" in the finale.

"Yesterday's Papers"

Yet another accident happened to me one day in a rehearsal of the Bartok. Doing an arabesque, I rolled over on my pointe shoe and fell onto the floor, landing chin first. I was dazed and, when I finally sat up from my prone position, Gerry looked shocked. He gave me a handkerchief, told me to hold it under my chin, and helped me up. Someone walked me to St. Vincent's Hospital (around

the corner from the studio) – I don't remember who - and left me in the emergency room. When several people who had arrived after me were seen before me, I asked at the desk what the problem was. "Mr. Joffrey said we were to wait for our best plastic surgeon to take care of you." That sounded serious. Brunie stopped by later, while I was still waiting, and she took me to the restroom, where I could see what was wrong with me in the mirror. A whole flap of skin was hanging down toward my chest and blood had stained my new blue leotard.

Finally, I was taken to a triage room where the doctor put eleven stitches in my chin – with no anesthesia – and sent me home. A few days later, Bob sent me to Dr. Manfred Von Linde, one of the foremost plastic surgeons in New York, to take the stitches out. While I was sitting in his waiting room, I looked at all the before – and – after photos on the walls. He took out my stitches and said he couldn't have done a better job himself. When I asked how much he would charge to 'fix' my nose, he said, "I don't <u>bend</u> straight noses." I went back to the studio and told Bob what the doctor had said.

"Don't do anything to your face! But you <u>could</u> have a breast reduction."

"I'm going to be a woman a lot longer than I'm going to be a dancer, and you're

 not going to mess with that."

My first tour began on October 5 in Durham, NH. On the way up, we were all given costumes to sew on the bus. I was given my roommate, Suzanne Hammons', for <u>Pastorale</u>. Afterward, I apologized to her. Needless to say, they never again asked me to put a stitch into anything that was going to be worn onstage. The next night, in Princeton, we performed everything in the repertory except <u>Peasant Pas de Deux</u> so that Columbia Artists, our booking agents, could choose what they wanted us to do. Françoise and Marie did five ballets that night, and the program ran some three hours. In their wisdom, they decided that America wasn't ready for the Bartok, so, my evenings from then on consisted of about five minutes of dancing. I practiced everything I knew before the curtain went up every night, Ballet Russe ballets, pas de deux, whatever. I was so frustrated, I even wrote to Bob, offering to dance the corps parts to relieve Françoise and/or Marie, who were doing all four ballets every night. I never heard from him.

On October 27, Bob arrived and was not happy with the program, and since we were soon to be in his hometown of Seattle, he was going to make some changes. The next night, he scheduled Jamie and me to dance <u>Peasant Pas de Deux</u>, which we rehearsed along with the Bartok. Bea Tompkins, our ballet mistress and ex-soloist of NYCB, danced <u>Soirée Musicale</u> for me, in order

to avoid an extra intermission. The next night, I danced both Peasant Pas de Deux and the Bartok and, for the first time in weeks, I was actually physically tired at the end of the night. Bob was careful to tell me that the change of program had nothing to do with my letter. I didn't care. I was just so happy to be working again. Everything went well, except that Jamie and I got a bad review for the pas de deux in Seattle. I was devastated until Jamie explained that the critic had always hated his teachers, Marian and Ilaria Ladre, and would never review any of their students well. The next year, I got a great review from the same critic (I wasn't dancing with Jamie), and I wrote him, attaching a copy of the previous year's notice with a note thanking him for his "encouragement at an earlier stage of my career."

Some cities really stand out in your memory. In Eureka, CA the first run movies – in 1959! - were Tobacco Road and The Grapes of Wrath. There was loud country music playing in the club of the hotel, right under my room. Not only did that keep me awake all night long, but there was no key to lock the door to my room in a hotel that appeared to be a brothel. Men kept knocking on my door all night and trying to push it open (I finally wedged a chair under the doorknob for safety).

In Bartlesville, OK, the bus got stuck in Fort Sill. A farmer, leaning on his rake, kept shaking his head as we drove by him on our way to – a golf course. We passed him again while heading for a bridge that we were too heavy to cross and yet again as we backed up about two miles towards him. Our bus driver finally asked him for directions. He must have thought we were crazy.

Two days in a row we drove miles and miles and arrived at our hotels at 4:30 a.m. and 3:30 a.m. Fortunately, we weren't scheduled to perform in those cities. Columbia Artists Management, as it did with the Ballet Russe, found ways to make us do impossible trips, sometimes as long as 400 miles a day on days we were performing, and even longer when we weren't.

In San Francisco, Jamie hurt his foot, so, for several performances I did the pas de deux with Paul and we cut a couple from Pastorale and parts of A La Gershwin. Then it was Nels's turn to get hurt, so no pas de deux because Paul did Pas des Déesses for Nels and Jamie did the other ballets for him. Next came Brunie – awful for the company and me. Bea warned me to be ready for Pas des Déesses the next day, and I was. You can imagine my shock when, instead of rehearsing me in it, she asked me to teach it to Mary Ellen. I refused – I was the understudy for Brunie, I knew it cold, and I was furious! Bea tried to teach Mary Ellen who should at least have known the Interludes that she was supposed to have learned as an understudy for Marie: they were the same

74

for everyone. Not only did she not know those, it was all Bea could do to teach her the opening and the coda. They actually left out one Interlude and her whole pas de deux. Bea was mortified and told me that Bob had said "absolutely not!" when she called to tell him Brunie was hurt and I was going to dance. His excuse was that they'd have to shorten the costume and that would ruin it, but the wardrobe mistress told him she figured out how to fix it without having to cut it, so, that couldn't have been the real reason. It took several more performances and hurried rehearsals before Mary Ellen was really ready to dance it and, by that time, Brunie was back.

The next night, Françoise taught company class because Bea was 'ill.' It turned out she'd had too much to drink. A while later, Bea and I had dinner together and she said, "I gave up a good career with the New York City Ballet because I really believed in Bob Joffrey. Now I think I made a terrible mistake. If he could do this to you, and to his own ballet, he's not the man I thought he was and I don't trust his artistic judgment anymore." Of all the things that Bob did to me, I think the Pas des Déesses episode hurt the worst because I loved the ballet so much and because there was simply no logical explanation for it. It also broke Bea's spirit: she started drinking, left the company after that year and never really came back.

Bob and some others came to our performance on Long Island, and he said he was "terribly pleased." In Holyoke, MA, both Marie and I fell on the too slippery stage – in front of our friends and families! Fortunately, we didn't hurt anything but our pride. Actually, Brunie was the Queen of Falls: she fell so often it became a friendly joke among us, but she had such a lovely smile when she got up that audiences loved her all the more. Unlike today's companies, we didn't carry our own floor on tour, and Françoise and I were in charge of trying to make it possible to dance on the shiny surfaces we found at the different theaters we performed at. People from the theaters would say things like, "We polished it just for you. Isn't it lovely?" We tried wax remover and lye to no avail. Coca Cola usually worked but made the stage sticky. (Just think of what it does to your stomach if it can remove floor wax so well!) Finally, we used rock rosin. I stomped on it to get rid of the lumps, and Françoise swept it across the stage.

There were many things that made life more difficult for us than it is for dancers today: the long bus tours, the slick stages of various sizes and shapes, the lack of pointe shoes that were personally crafted for each dancer (mine were stock shoes, right off Capezio's shelf). We certainly had a lot of excuses for bad performances. The other ballets had live music whose tempos might

be too slow or too fast, so you could blame the musicians, but the Bartok was recorded. When I came offstage after that, I couldn't blame anyone for a bad performance. It was all on me!

The tour was finally over on December 12 in Poughkeepsie, NY. The bus took us home. Most of us slept all the way, and things returned to normal. I applied for Unemployment Insurance, started taking classes, and had a meeting with Bob, Alex Ewing and Barbara Johnson, the company manager. Bob was very complimentary one minute and scathingly critical the next, and we got several misunderstandings straightened out.

On December 31, Jamie and I joined the crowds of people in Times Square to welcome the New Year – my first time. It was freezing but exciting. I was madly in love with him, but was not so sure how he felt about me.

Act Two, Scene Two

The Robert Joffrey Ballet

Good-bye to the 50s

1960 started out the way 1959 ended between Bob and me. We began rehearsals for our next tour with some good news for me: I was to dance Balanchine's Pas de Dix (to be called Raymonda in order to avoid confusion with Pas des Déesses) with Jonathan Watts. Not so much, as it turned out. We also began learning Fernand Nault's (ballet master of Ballet Theatre) version of La Fille Mal Gardée, originally choreographed by Marius Petipa. At first I learned the corps of Fille. Mary Ellen was to perform the leading role of Lisette, which I absolutely knew was one that I should be dancing. When Brunie arrived, she took my place, and I was told that Mary Ellen and I would alternate as Lisette and a Gossip. Then I was informed that I would only be dancing the Gossip, a mostly mime role that wasn't even on pointe. Since Pas des Déesses and Pastorale seemed to be off limits for me and it quickly became apparent that Brunie, not I, was really to dance Raymonda, that meant a whole rehearsal period and tour with my not dancing anything on pointe! All I could think was that, if something happened and I had to go on in someone else's place, I wouldn't be in shape to do so. I was miserable and my friends, Jamie, Marie and Paul, were furious on my behalf.

When Vida Brown, a ballet mistress of NYCB, came to set Raymonda I was, indeed, only an understudy, but I learned everyone's part. Rehearsals weren't going so well: Brunie, Françoise and Marie, all of whom were supposed to learn the leading role, were slow to translate learning the steps into dancing them. Vida liked me, but it was obvious that Bob didn't want me to dance the ballet – he thought Balanchine would be horrified with my body (I was short and round instead of tall and slim). Barbara Johnson, our company manager, told Bob I wouldn't be able to fit into any of the tutus Mr. Balanchine had given to our company for the ballet. When I finally tried them on, the one that fit me best was slender Tanaquil LeClerq's!

The Fille rehearsals were not going so well either. Mary Ellen seemed to be getting weaker as they went on, not stronger, as she should have been. One day Fernand, with no warning, ordered me to dance the second act pas de deux with Gerry. Something had told me, just the day before, to stay and watch a rehearsal of it, so, I was able to dance the first three steps (before he stopped me) without a mistake. Fernand's nasty response: "You think you're rather sharp, don't you"? Oh, dear!

The night before tour was to begin, as I was at home packing, the phone rang. It was Bob. "Can you come to the studio immediately? Mary Ellen has pernicious anemia. She won't be going on the tour, and you'll have to dance Lisette tomorrow night". I grabbed my pointe shoes and practice

clothes and taxied to the studio for what I expected would be a long night of rehearsing. <u>Fille</u> in that version is an hour long, with no intermissions, and Lisette is onstage for all but two minutes. Instead, I spent hours standing while the costume was being fitted on me (Mary Ellen was at least three inches taller than me and flat in the front). At two in the morning Bob sent me home to finish packing. "See you on the bus"! Needless to say, I didn't sleep much that night.

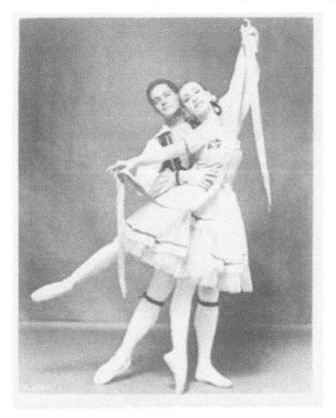

Gerald Arpino and Me in "La Fille Mal Gardée"

The next day, after a fairly long bus trip to Stoneham, MA, I found myself, for the first – and only – time in the company, in a soloist's dressing room. Bob told everyone not to speak to me, because it might make me nervous. Both Bob and Fernand were there, but they never said a word. Bob didn't even approach me with his Yardley's Lavender Brilliantine to smooth my hair. He usually carried it in his breast pocket to make sure our hair was neat and shiny. That night I made my own decisions as to makeup and hairstyles for the ballet. My family drove up from Boston, and several of my dancing school friends were there, too, to see what I figured would be, at best, a sketch of the ballet. I really didn't think I knew it and Gerry wasn't the best partner in the world, although he was otherwise perfect for the part. As it turned out, the only step I missed was the series of fouettés at the end of the second act variation. I did them on demi-pointe because my left

leg simply refused to rise onto pointe. And I'd always been able to do fouettés in my sleep! In fact, before I joined the Joffrey, I was invited to join Ballet Theatre to dance the "competition" in Graduation Ball, which part consists entirely of – you guessed it – fouettés! I was angry at myself and embarrassed, but the audience didn't seem to notice and Bob didn't say anything afterward. In fact, neither he nor Fernand spoke to me at all after the performance. They should have been thrilled that I was able to get through the ballet at all as we had to perform it every night: the other three ballets together weren't long enough to make up a program. I thought I must have been awful, but my colleagues were very complimentary and the audience seemed to love the ballet – and me in it!

The next performances were better except for the darned fouettés. I simply hadn't had the rehearsal time to build up the strength in my left calf. That was the leg I'd broken in the Ballet Russe. It took a while before I was able to accomplish them to my, and Bob's, satisfaction, but he did start to give me notes and corrections and treat me like the other dancers. He also brought me a gift one night: a salt and pepper set shaped like little butter churns, exactly like the large one I used in the ballet.

All this time, Brunie was still rehearsing Raymonda, with coaching by Bob, but she kept insisting that she wasn't ready to dance it. Jonathan was on tour with us, being wasted. He had nothing to perform, although he had begun to learn Fille. He and I began surreptitiously practicing Raymonda: he had been very complimentary about Fille and probably figured that I was the only one who could be ready to dance the Balanchine any time soon. Ten days after the tour started. I was sewn into Tanaquil's costume, and Jon and I danced Raymonda. Gerry and I also danced Fille. I was very tired, but exhilarated. I loved both ballets.

The next several nights I danced both ballets, but Bob gave me so many notes that I never had time to work on them. He became angrier and angrier as he felt I wasn't improving. One night Jon said, "You know, Bob, if you'd just let us have a few minutes to rehearse instead of giving Chellie all those notes right until curtain time, I'm sure we could do better." Bob stopped, and we did do better!

One afternoon when we reached the theater, the truck carrying our stage crew, costumes and scenery hadn't arrived. That was odd because the stagehands – and the truck – left after every performance and drove straight to the next town, usually getting there in the morning. Several

phone calls finally explained the problem: they'd gone to Greenville, SC, but we were scheduled to perform in Greenville, NC. The performance finally went on, although it started quite late.

In Chicago, as Paul and I took the elevator to our rooms, we heard someone singing in the lounge, someone really good. We hurried back down and found Anita O'Day, the great jazz singer, practicing for a show she was working on. She let us stay and listen to her. It was glorious! We had a long talk with her and discovered that she'd always wanted to be a dancer and, when she found out who we were and where we were performing, she came to see us that night.

In Sheridan, WY, there was a blizzard and the tiniest stage ever. We had to use a narrow spiral staircase to get to the dressing rooms, which were below the stage. I'm afraid of heights; so, I wasn't too thrilled by that, but I needn't have worried. I had a very bad cold and the stage was so small that it was decided that we not try to do Fille.

I had the only 'free night' ever in the history of the Joffrey Ballet up to that time! They sent me back to the hotel, where there was no TV, no radio and no restaurant. I slipped into bed while the company performed its short program – all three ballets lasted only an hour in total. They must have had long intermissions! When my roommate, Suzanne Hammons, got back, the dear thing brought me some cake from the party that had been tendered the company. Thank heavens – I was starved by then!

Jonathan danced his first Fille with me in Detroit. He was adorable in it, and what a partner! I wasn't nearly as tired when I danced it with him because he helped me so much in the pas de deux. I quite fell in love with him. As a contrast, one night when Gerry danced it, he forgot part of the pas de deux and I was literally left on my own until he woke up. The corps dancers kept telling me that he wasn't with me all the time!

A few nights later, Brunie danced her first Raymonda and Diane Consoer danced Grahn in Pas des Déesses. Did I get to do the Cerito that I knew and loved so well? Not! Marie moved over from Grahn to dance it. There were also lots of cast changes in Raymonda, so, several of the girls got a chance to dance the lovely variations.

In Sacramento, with Bob in attendance, we danced all four ballets – what a long program that was – so that he could take a good look at the repertoire. The result: things stayed pretty much the same as they had been. Two days later, in San Francisco, Bob gave us all flowers. Mine were three white carnations, different from everyone else's. We next played at Hollywood High School!

The tour ended in California and I stayed on to visit with my Ballet Russe roommate, Bobbie (Yvonne) Craig, who was dating the man she later married, the singer Jimmie Boyd (of All I Want for Christmas is My Two Front Teeth fame). I got to see his house that hung off a cliff in the Hollywood Hills and to hear him say, when he was looking in the mirror, combing his hair, and his pompadour wasn't behaving the way he wanted it to, "C'mon, God"! I also took classes at Eugene Loring's American School, where the staff was highly complimentary about my performances and, as a fellow Ballet Russe alum, I got to watch Cyd Charisse's private lesson. What a beautiful body she had!

Back to New York for Unemployment and classes, where Bob continued to alternate between sarcasm and compliments to me. In fact, he was so cruel to me once that I actually left the school for a while and went back to the Ballet Russe School, Ballet Theatre School and Madame Elisabeth Andersen. When I came back, I did more notes for Bob's convention classes and said goodbye to Marie, Paul, Mary Ellen and Dick Beatty, who left us for a foreign tour with Ballet Theatre. I celebrated my 22nd birthday by learning Hebrew Folk Dancing from Fred Berk at the 92nd St. YM-YWHA every Wednesday night, taking piano lessons from Bob's class pianist, Sally McBride and visiting the Metropolitan Museum's beautiful exhibits.

We started rehearsals for the summer at the beginning of June. At the Jacob's Pillow Dance Festival, we were to share a program with Indrani, an East Indian dancer, and her company. Appearing with us, since Ted Shawn, the Director of the Pillow, didn't think the Joffrey Ballet alone would sell enough tickets, were to be Michael Maule and – Maria Tallchief! I wondered if she would remember me – she did! We were to dance Pas de Dix (with Maria), Pastorale (Sarah Leland of the Boston Ballet) and the world premiere of Thomas Andrew's Clarissa (also with Maria). Since I wasn't cast in any of the ballets, it looked as if I wouldn't be dancing at the Pillow at all. The problem was that Tommy would have to choreograph his ballet before Maria was due to arrive, so, he asked to use me to set it on.

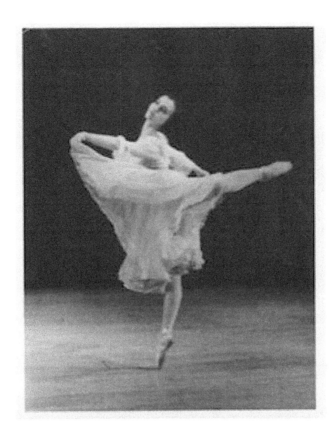

Title Role in "Clarissa"

We began rehearsals, and it was technically very hard, variation after variation and three pas de deux to Ravel's Piano Concerto for the Left Hand Alone. I read the book on which the ballet was based (<u>Clarissa</u> by the English novelist Samuel Richardson) and worked with Michael as my partner. Tommy was worried that he wouldn't finish the ballet on time, Michael was hostile because of working with a neophyte choreographer and I was in the middle. When I heard that Rita Bradley, not I, would be doing Louise in Bob's <u>Carousel</u> at Chautauqua – with coaching from Bob! - I asked for a meeting with him. I got a lot off my chest and he assured me that he was still fond of me and that I'd get to dance <u>Clarissa</u> in Chautauqua when Maria would not be with us (as it turned out, we wound up not doing it there). The days were difficult: usually two classes and four or five hours of rehearsal. Gerry was playing Clarissa's father, which was all right when I was dancing but would be a stretch with Maria – he might not look old enough or be tall enough. All of a sudden, Tommy got angry with me (the Dirk Sanders situation all over again) and I didn't know why until later: Bob kept insisting that Maria should dance it. Tommy wanted me, so I had to be perfect to convince Bob. Nobody's perfect.

Maria still hadn't appeared, so I was rehearsing both of 'her' ballets, but I still had no contract. I had costume fittings for the new ballet but even one week before we were due to leave for the Pillow, our company manager was still saying that Bob hadn't decided whether to take me or not. Besides, I was living on the edge: Bob had sent me to his Dr. Zea to give me thyroid pills (there was nothing wrong with my thyroid) and 'water' pills to make me lose more weight. By then, I was down to less than ninety-five pounds, but that wasn't enough for Bob. He wanted me to be ninety pounds.

Maria finally came to watch a rehearsal of Clarissa and, as in the movie The Turning Point, she said to Tommy, "Let Chellie do it. She's wonderful in it, and I don't want to work that hard anymore". Still, no contract; I really lost it when everyone else was asked with whom they wanted to room – but not me because it hadn't yet been decided if I was going! I got dressed and left the studio – fuming! When Bob called me at home to ask where I was going, I said, "Florida – for a vacation with my parents." And I wished him luck because we both knew nobody else could dance that difficult ballet – or fit into the lovely little costume that had been made for me. He chuckled and said that of course I was going to the Pillow, and of course, I was going to dance Clarissa there – he said he really liked me in it – and the upshot was that he apologized to me. Meanwhile, Ann Barzel wrote a column about American dance in the Sunday New York Times that reviewed only Paul Draper, the famous tap dancer, and me by name.

By the time we reached the Pillow, I was feeling pretty awful – dizzy and faint – and when Bob lectured me in front of the whole company, I broke down. My parents had arrived and they took me to a doctor recommended by Papa Shawn. Dr. Milton Lowell told me to stop taking those pills, to drink as much water as I could and to add salt to all my food: I had been leaching the salt from my body with Dr. Zea's stupid combination of pills. It took a few days of what I considered less than stellar performances but by the weekend, I was feeling myself again. Oh, and I'd made it to ninety pounds.

Bob gave me an artistic correction that I tried one night even though I just knew it was wrong. After that performance, Bob told me I had been right and I should do it my own way again. Unfortunately, that was the performance that Doris Hering saw, and she was the one critic who didn't give me a very good review. Bob gave me flowers and a card that said I was wonderful in the ballet! So many people came to see us, from Boston and New York, including critics, dancers and – best of all – Harriet Hoctor, my first teacher. She was so proud of me and said I "looked like

Pavlova (the greatest ballerina in history up to that time) – and moved like her." She actually cried. All in all, the week was a spectacular success for the company and for me personally. I also learned some East Indian dancing from Indrani's dancers, Bali Ram and Narasimha Rao, and her guru Deva Das. What a remarkable place Jacob's Pillow is!

Back to New York and more Unemployment. Michael Maule asked me to help him demonstrate and teach his version of <u>Die Puppenfée (The Fairy Doll)</u> for Lucille Stoddart's Dance Congress, so we began working on that. Teaching it at the convention was not only fun, but it enabled me to make several good contacts for future teaching, choreographing and performing opportunities. Classes with Bob continued to be wonderful, and I continued to learn something new from him every day. He did lecture me one day about being more 'classical': he thought I was 'performing' too much in class. I took that to mean I shouldn't be showing my love of dancing and beautiful music so much. In fact, he ordered the pianists to play less 'inspiring' music. When I asked one of them who composed the particularly boring piece he was playing, he said,

"This composer was a contemporary of Mozart. He just isn't as well known".

"He isn't as well known because his music is lousy!" was my answer.

One day, Bob called me into his office to tell me that he was going to pay me $30 extra to stage <u>Fille</u> for Chautauqua. As usual, many of the regular company members had decided not to join us for the short summer tour, so it would be an almost entirely new cast, except for Gerry and me. I began immediately and things went quite smoothly. When Bob watched a run-through, he was very complimentary, but it was hard for me to do my own dancing as well as worry about everyone else and the production as a whole. It was certainly worth more than $30!

At Chautauqua, Bob asked me to teach company class several times and I danced <u>Raymonda,</u> <u>Fille</u> and the Peasant Pas de Deux. We also learned Bob's version of <u>Carousel</u>, where I played Miss Snow. Things that went wrong: I couldn't help crying during "You'll Never Walk Alone" at the end of <u>Carousel</u> (we're not supposed to hear Billy Bigelow in that scene, but it's so beautiful;) in the last act of <u>Fille</u> when Mama is supposed to throw me into my bedroom, I pulled away as hard as I had with Françoise, but Suzanne was so much lighter the audience burst into laughter. Only afterward did I find out that I had pulled her off her feet and, like Mary Poppins, she flew in the air parallel to the stage! Oh, and Gerry got locked into the closet that served as the entrance to my bedroom and I had to run around beside and behind it (the door was locked and I couldn't be thrown in) only to find that he'd somehow cut out the side of it. There he was inside while I was

outside, and we had to emerge together with straw in our hair as if we'd been engaged in hanky-panky on my straw bed. Needless to say, we really enjoyed that performance. So did the audience, and Bob was very pleased, too.

Back to New York and Unemployment again and more difficult talks with Bob. How quickly he seemed to forget all the good work he'd complimented me on. I was also hired by Lucille Stoddart to write the notes for and teach La Fille Mal Gardée for her convention – more good future contacts. We also had an AGMA (American Guild of Musical Artists – the dancers' union) meeting at City Center – we were on strike! For a very short time, however, as Julius Rudel, the artistic director of the New York City Opera, accepted our demands the same day. A week later, Senator John F. Kennedy spoke to us at a meeting at City Center, too, and I was very impressed by him.

We immediately began working on Claudio Monteverdi's Orfeo with Christopher West as our director and the great Leopold Stokowski as our conductor. This was a huge production, and Bob had a lot of choreography to do. I was cast in the corps de ballet, but the work was exciting because of wonderful singers, the director, and Stokowski. We did have a major problem, however, because Stokie insisted on using 'original' instruments for the orchestra. New York City in Indian summer is very hot and very humid and City Center had no working air conditioning at the time. Our first orchestra rehearsal of the 65 minute opera took four hours because the instruments simply couldn't stay in tune and their pitches didn't match those of the singers. Stokie and Chris West fought all night long. Needless to say, we finally dumped the 'original' instruments and settled for modern ones.

During the run of the opera, Nels and Jamie were robbed of their paychecks in their dressing room, and Nels' apartment was also robbed while he was at the theater one night: he lost everything. The rest of us pitched in to give them enough to live on until the next payday. We women also discovered something interesting: from the windows of our dressing room, we could see into an apartment across the street. It belonged to Anthony Perkins, the movie star, and we had a good time watching the handsome actor at home.

Meanwhile, Bob had me take rehearsals of La Traviata and Carmen with Gerry and Françoise dancing the leading roles. Being the professionals that they were, they took my direction with no problems. I also rehearsed Rigoletto with our replacement dancers in that as well as Carmen, for which I had to make several changes for the conductor. Did Bob hold me out of solos in Orfeo so

that I could do all this extra work? He never said, and I never asked. In hindsight, it certainly made sense that, later on, he would make me ballet mistress of the company. Was this his way of training me for that job? If he'd told me what he was thinking, it might not have been so hard on me emotionally.

Having heard Senator Kennedy at the meeting at City Center, I was determined to vote for him in the coming presidential election. One small problem: since I hadn't finished high school, I had nothing with which to prove I could read. So, I went to a local high school to take a Literacy Test. I waited outside the door of a classroom with several others while the group ahead of us was taking the test. It took them forever! I was beginning to be afraid that I would fail and not be able to vote. When we finally went in and were given the test to fill out, it took me about three minutes. I brought it up to the monitor, who asked, "Is there something you don't understand"?

"No, I've finished." I passed. I was now legal to vote, and I did in my first election ever.

Next, we flew to Dallas in a luxurious private plane for a season with the Dallas Opera. Our company had to be enlarged for these performances, so Bob hired several new dancers, unfortunately including my nemesis. The opera was George Frederic Handel's Alcina, and it was the great Joan Sutherland's first appearance on an American stage. Franco Zefirelli directed, the entire production was brought from the Teatro Fenice in Venice (including all the costumes and even our boots) and the choreographer was the Yugoslav Ani Radosevic.

Zeffirelli treated the dancers like children: he was so rude to us – at first. Later, when we proved to be more professional than the singing chorus, he was very sweet to us. We were all impressed by Sutherland's glorious voice and her professionalism. After the first performance, Neiman Marcus threw us a glamorous party at the City Club of the Adolphus Towers, with Greer Garson in attendance. Dallas was a 'dry' city, but private clubs could serve alcoholic beverages, and we found several bottles of expensive champagne at each table. The result: Vicente Nebreda got sick; Helgi Tomassen passed out; and Nels Jorgensen was arrested on the street for being intoxicated – and spent the night in jail!

We were in Dallas during the election, and it was very strange: everywhere we went we were accosted by young women trying to pin Nixon buttons on us. Also, all the bumper stickers and window posters were for Nixon. Several of us spent the night of the election in Marie Paquet's and Paul Sutherland's room, eating popcorn and watching the returns. When we finally went to sleep, early in the morning, the winner hadn't yet been declared. I was awakened by a phone call from

Paul. "Kennedy won"! The strange thing was that all the Nixon posters and bumper stickers had been replaced by Kennedy posters and bumper stickers. It was really weird, and the thought came back to haunt us a couple of years later.

Back to New York again, where Miss Moore arranged for me to be a guest lecturer in Walter Sorell's Dance Theory and Appreciation class at Columbia University – and me without even a high school diploma! My Dad really loved that. We began rehearsals for the next tour, teaching Fille to the new company members. We actually danced it at the 92nd Street YM-YWHA for a Producers' Showcase, on that really small stage, and I got a wonderful review from the great comedic dancer Iva Kitchell out of it.

Bob called me into his office to tell me, with a mischievous look in his eyes, that we were going to do Lew Christensen's Con Amore and that I was going to be in the corps de ballet. He looked more than a little deflated when I said, "Great! At last, I'll be onstage without the spotlight on me, so I can relax and just have a good time." As it turned out, Una Kai (ex NYCB), our new ballet mistress, arranged for me to do a tiny part as one of the two Guards.

The other ballets for the tour were Pastorale, Pas des Déesses, Raymonda, La Fille Mal Gardée, Tommy Andrew's new Invitations and Balanchine's Allegro Brillante. Since I was positive I wouldn't be dancing the first three, I had to count on the others for my tour repertoire. In Tommy's ballet, Marie and I learned the big pas de deux with Gerry. Tommy wanted me to do it, but Bob was insisting on Marie. Sound familiar? Tommy won easily this time by giving Marie a beautiful big waltz at the end of the ballet. My pas de deux with Gerry was beautiful, too, and our lovely costumes were borrowed from the Metropolitan Opera Company.

Allegro Brillante rehearsals began with only the four corps de ballet couples. When I wasn't called, I wasn't worried: I knew I would be dancing the leading role – I just knew it. I was technically the strongest dancer in the company and the role required a strong technique. Besides, I'd already proven I could dance Balanchine by my performances in Raymonda. But I wasn't given the role. Instead it went to Brunie and – my nemesis! As devastated as I was, Jamie was more so. He insisted I talk to Bob about it, and I did. Here was Bob's ultimate cruelty so far. He said, "Both of them will dance it better than you. If you can prove you can dance it better, you can do it". Of course, he never gave me the chance to learn it, always preventing me from attending any of the rehearsals. He was also furious with me for suggesting that, since we were no longer going to be dancing Fille every night, I didn't have enough to do – just like the first tour without the Bartok.

His guilt over his treatment of me caused him to be in a foul mood throughout the rehearsal period. He took it out on all of us, but especially on me.

I took a day off to rehearse <u>Die Puppenfée</u> in Elmira, NY and, when I returned to the company, there was a surprise for me: Bob had had his protégé, Warren Ruud, make new "feet" for me. They were constructed of latex and were flesh-colored and, when glued to my insteps under my tights, they improved the shape of my arches. I at first stubbornly refused to wear them, but Paul Sutherland was sent to try to persuade me.

"Did Vicente ever do anything to get his beautiful feet?"

"No."

"Do you work your feet hard all the time?"

"Yes."

"Well, you're going to have beautiful feet someday, too. Why shouldn't audiences see them now?"

"Okay, Paul. Good job. Tell Bob he was smart to send the only person who could talk me into wearing the darn things."

And I did wear them, at least until I convinced Bob that they caused my insteps to perspire so much that I was probably losing what arches I already had. By the way, working on my feet meant doing the 81 (yes, 81!) foot exercises that Bob had given me to do. I had exercises to do if I took a bath; I had exercises to do if I took a shower instead; I had exercises to do if I had a seat on the subway; I had exercises to do if I had to stand on the subway; I had exercises to do before, during and after classes, and I did them all – every single day.

Highlights of the two month tour which began in Hempstead, LI, on January 21, 1961: we did two performances of <u>Fille</u> in Hempstead, but the new conductor's tempos were wrong and he was so embarrassed he refused to take his bow. In Pittsfield, MA Bob was so angry he gave one of his severe lectures to all of us. We must have needed it because we immediately started to do better. In Rocky Mount, NC, Françoise, Brunie and I were each presented with a dozen and a half roses. In Savannah, GA I saw something that I shall never forget: six black men chained together being marched down the middle of the street. I guess before that I never understood what being on a chain gang really meant – or what it would look like: horrid!

In Simon's Island, GA, we stayed at a beautiful resort and had a much-needed free night. In Brunswick, GA, at a party after the performance, one lady admired my Lisette so much that she gave me her own corsage. In Winter Haven, FL, the bus left Jamie and Paul at the theater after performance because they were so slow getting dressed. They had to walk all the way back to the hotel, but they didn't seem to mind: I think they considered it an adventure of some kind. In Miami Beach I danced my best <u>Fille</u> of the tour, even doing triple pirouettes but, when I got on the bus, Bob said, "You probably think you were very good tonight. Well, you weren't. And, by the way, Irina Baronova (one of the "baby ballerinas" of the Original Ballet Russe) used to do five pirouettes"! The next night, in Miami, I did five pirouettes and this time, when I got on the bus, still in makeup for the trip back to the hotel, all Bob said was, "Come here. I thought so: one eyebrow is higher than the other".

In New Orleans, the wonderful old theater had a very slippery parquet floor for a stage and I took a hard fall in <u>Invitations</u> and slid on my back right between Gerry's legs in our pas de deux. We wound up looking at each other with astonished faces, I looking up and he looking down. The audience applauded when he finally helped me up and we finished the dance: it must have looked worse than it felt.

The premiere of <u>Allegro Brillante</u> with Brunie took place in Hammond, LA, so I very happily got a chance to dance <u>Raymonda</u> again as well as <u>Fille</u>. Between the matinée and the evening performances, we all ate at the college cafeteria: 85 cents for a whole meal! It was pouring rain outside and, when we got back to the theater, we discovered a huge puddle in the center of the stage from a leak in the ceiling. It took until 9 p.m. to dry it up, not completely, but sufficiently for us to dance. Gerry and I spent most of <u>Fille</u> rechoreographing as we went, in order not to hydroplane into it. In Hopkinsville, KY, my worst nightmare happened: I only danced <u>Con Amore</u> that night and didn't even work up a sweat. I was miserable. In Chicago, the Ballet Guild again tendered us a reception at which Ann Barzel, renowned dance critic, showed us her film collection, including one of Baronova in <u>Fille</u>. She was wonderful in it, but she hadn't done five pirouettes that night!

For a few days, Rita had complained that her foot was hurting her, and I was told to take a look at her as Cupid in <u>Con Amore</u>, just in case. First of all, there was no way I could do that as I was onstage, in no position to see her, the whole time she was dancing. Secondly, there was no one to replace me. Besides, I didn't want to ask her to teach it to me on the bus: it was, after all, her only

solo, and with my reputation (I'd go on in someone's part and do it well enough that they would have to share it with me thereafter) it didn't seem fair. What was also not fair was that, yet again, I was being asked to do something without adequate rehearsal. Note those last three words.

In the Milwaukee performance, after Allegro Brillante, Diana Cartier came running upstairs to my dressing room.

"Chellie, Rita sprained her ankle and you'll have to go on as Cupid."

"No, I won't. Rita would rather die than not dance it."

I waited as the girls ran upstairs to change for Con Amore: one pair of toe shoe clad feet, two, three, four – where was the fifth? From a balcony outside my dressing room door I looked down onto the stage, and there lay Rita, clutching her ankle and moaning. Oh, God: I had twelve minutes to prepare to dance a role I knew nothing about – nothing at all. Shades of the Ballet Russe and Sombreros. Besides, I still had to dance my own part in the ballet.

Cupid's entrance was in the third movement of the ballet, so I danced my own first movement, listened during the second to Rita trying to explain – from her perch on the balcony, seated with an ice pack on her foot – what I was going to have to do. I then went on stage in my own part in the third movement. When I came offstage, the costume mistress got me into Cupid's tiny costume and asked me when I was supposed to go onstage.

"During the blackout."

"You mean THIS blackout?"

Yes, I'd missed my entrance. That was just the beginning of the evening's hilarity. Each girl enters carrying a large tree, so instead of two legs peeking out from under each tree, one of them had four legs – it was the only way I could get to my place onstage. I already heard Una laughing in the audience.

I madly improvised the solo stuff, but real chaos ensued when I had to interact with the rest of the cast. Cupid is like Puck in A Midsummer Night's Dream: she is supposed to connect all the errant couples with the right partners. Let's remember that I didn't see very well – problem #1. Problem #2 – Rita was shouting at me, "You sauté (jump) out of the square for four counts, then back to the center for four counts and repeat that pattern." All was well and good, but I was counting fast counts when it was supposed to be slow ones. That meant that every time I tried to sauté out, I bumped into one of the couples dancing in a square around me. Because I was doing

my part with great energy and attack, I trampled all over them, causing them to trip and mess up the choreography, looking all the while as if something was terribly wrong. By this time, the audience suspected that something was amiss – the ballet was supposed to be funny, but maybe not this funny.

The one thing I knew – really knew – was a bit near the end, when Cupid shoots her arrow at the shy Student, who then falls in love with her (in order to tidy up all the couples). I shot Larry Rhodes who, knowing about my bad eyesight, shouted as he ran across the stage towards me,

"I'm coming. I'm coming".

"I know, I know."

You see, I'd decided to wait until the last possible moment to run away from him as he chased me: I thought it would be funnier that way. It was funnier, all right. When he caught me, he and the Sailor and the Roué were supposed to lift me overhead. By that time, they, as well as everyone else onstage, and Una and the rest of the audience, were convulsed with laughter. Oh, they got me up, but then we all collapsed in a heap, ruining the last pose. When Una got backstage, she was wiping tears of laughter from her face. The review in the newspaper the next day said, "The dancers seemed to be having an even better time than the audience." Oh, dear. That was the only time I danced Cupid in Con Amore. I told Rita not to even think of missing another performance!

The doyennes of dance in Dayton, OH, Josephine and Hermene Schwarz, came to our performance at the National Cash Register Auditorium and were so impressed by my Lisette that we struck up a friendship that lasted until their deaths and resulted in my working with the Dayton Ballet several times later in my career. In Rome, NY, Bob began working with Larry and me on some exciting new choreography, but unfortunately nothing ever came of it. The tour ended in Elmira, NY, where I stayed with Mme Halina and her husband and – cooked my own dinner! It was, in a way, getting me ready to be back home in my own apartment, living a more 'normal' life for a while.

Back to New York and Unemployment yet again. The mayor of New York City, Robert Wagner, decided to bring some culture to the children of Harlem, and he chose the New York City Opera and the Joffrey Ballet to perform for them at Carnegie Hall. The opera company presented Gian Carlo Menotti's The Telephone, and we danced La Fille Mal Gardée. It was a very difficult day for us, especially for Gerry and me, as we had to be at the theater, already in makeup, by 9 a.m.

for barre and spacing rehearsal. It was worth it, though. When the curtain opened in the performance, the children in the audience (that is, the boys) started to whistle and make nasty comments about our girls in their knee-length tutus, but by the end of the ballet they were clapping and whistling – in appreciation. The best thing about the whole day was the last of the many bows we took, when the house lights came up and I realized that we had really been dancing in that incredibly historic and beautiful theater.

One day at the studio, Bob, Paul and I had a long discussion about technique and dancers. Things like that didn't happen in the Ballet Russe! It was exciting to understand, yet again, that we were all on the same page and shared the same interests and opinions. Another day, the great Danish dancer Fredbjorn Bjornsson watched class: more about that in a minute. Just in case you think that dancers know – and care – little about the outside world, I noted in my journal on April 12, 1961, that the Russians orbited a man in space and that it was the second day of the Adolph Eichmann trial in Israel.

Freddie Bjornsson was engaged to teach Bournonville classes for two weeks. August Bournonville, like Enrico Cecchetti, had a different class for each day of the week, and they got harder as the week went along. Freddie taught us the Wednesday Class – not too hard, but not too easy either. After the second day, he drew Larry and me aside and asked us if we were Danish or if we had studied this technique before. The answer to both questions being no. He shook his head and said we were dancing like real Danes. You can imagine my surprise when Larry and my nemesis were called to learn the pas de deux from The Flower Festival in Genzano, not me! Lillian Moore was as shocked as I was and casually mentioned to Freddie that I was available to learn it, but nothing came of that. Meanwhile, I continued to do well in his classes. One day he even stopped the class to say I had done the combination "Il Bacio" perfectly.

John Wilson and Gerry decided to do a joint concert at the 92nd Street YM-YWHA in May. John, Brunie's husband and one of the original six dancers in the company, was really a modern dancer, and his humor was infectious. His pieces that night, including one where he portrayed a lawn sprinkler, were hilarious. Gerry had two pieces on the program, Ropes for Brunie and six men, and Partita for Four for Rita and three men. The latter was a well-constructed abstract dance for four young people, using their bodies and their talents very well. Ropes was a dark piece containing several striking moments, one of which had Brunie caught up in the ropes as if she were being crucified. There was to be a brief blackout at that point, during which she was supposed to

slide down to the stage and free herself from the ropes. Problem: her beautiful, very long, thick hair got caught and she couldn't get down. As the blackout got longer and longer, we realized something was wrong. Suddenly, we heard a loud whisper from Brunie, "Get a pair of scissors!" When the lights came up and the dance continued, there were clumps of her hair clinging to all the ropes. These were the first of Gerry's pieces that we had seen, and many of us, including me, were a bit surprised by how good they were. Afterward, several of us were invited to a party at Charlton Heston's apartment at 5 Tudor City Place. Unfortunately, he wasn't there.

Bob had no work for us that summer, so when Joyce Trisler asked Jamie and me to do a summer stock season, we "auditioned" and were hired, I as Dance Captain, and we began read-throughs and rehearsals of the first of the two productions our company was to do, Rudolph Friml's The Vagabond King. There were six dancers: Patti Turko (Pennsylvania Ballet), Nancy Stevens (Martha Graham Company) and I, Tony Valdor (San Francisco Ballet), Jack Leadbetter (Ballet Theatre School) and Jamie, with David Tihmar as director, Abba Bogin as musical director, Joyce as a choreographer and Jack Cassidy as the star.

We soon found out that Actors' Equity was quite different from AGMA. For instance, Equity allowed eight hours of rehearsal a day, while AGMA only permitted 30 hours per week. (Never mind how much we rehearsed for Joffrey – since we weren't paid until the last week of rehearsals, we only observed AGMA rules for that week, even as to five minute breaks every hour. In fact, Bob said he'd give us a free class for every hour of unpaid rehearsals, and he chuckled when I told him my grandchildren would probably be eligible for those free classes.) Equity also required that housing during summer stock (for which we had to pay) could cost no more than $15 per week, so, we stayed in people's homes, usually with kitchen privileges. In the ten weeks I was on that tour, making only $90 a week, I saved $500. Equity also had a rule that we weren't allowed to schedule classes. That didn't sit well with our dancers, all of whom were, or wanted to be, professionals in major companies, so, we worked out a deal with our stage manager, Barry. He would drive us to the tent every morning for a "union meeting" (aka class), which I taught. At one time, I guess, a choreographer must have taken advantage of the classes to work out choreographic ideas, thus giving him or her an extra hour or two of unpaid rehearsals. Otherwise it made no sense for dancers to rehearse without class, unless you wanted them to be injured.

Owings Mills, MD, was where we began rehearsals and did our first performances. As soon as we got there, we were given copies of the musical score and told to learn the songs. Being anally

retentive, I did so immediately and, as David finished blocking each number and he asked us to do them "off book" (by heart), only one reedy voice was heard onstage – mine! None of the singers or the other dancers were ready. I wasn't sure how Abba felt about that because, whenever he looked up at me from the orchestra pit it seemed as if his eyes were crossed. (I later found out that he really did have an eye problem.) Joyce was working us very hard on the dance numbers but, when we were asked if we would be willing to help the stars with their lines, I immediately volunteered to do so. After all, why not learn as much as possible whenever you can? I was fortunate enough to be given Jack Cassidy as my "partner" and I worked with him at night after rehearsals until he was letter perfect.

The first time we ran the "Song of the Vagabonds," Jack made his way around the stage, stopping at each singer and dancer. We were all supposed to react to the line that came our way. Since I knew all the music as well as the words, I figured out what line would be 'mine' and I made a bold movement to illustrate "Break the ties that bind you." Shelly Gross, one of the show's producers, happened to be there that day and he stopped the rehearsal to ask, "Who is that young lady? The rest of you better watch her because she's going to be a star someday!!" And David constantly used me as an example of how to think, listen and react onstage. I was really having fun as well as saving money and losing weight: what a good summer! Near the end of the run, Jack drove me to New York for a night, where he bought me a thank-you gift of a bottle of Miss Dior perfume. I wear it to this day.

The last weeks were really hard as we were doing the eight hour rehearsals of our next show, The Merry Widow while still performing Vagabond King. It's funny: David Tihmar had told us that we would come to love the Friml (some of the chorus members were disappointed to be doing such an old-fashioned show) and would even cry when it was over. Cry? We were all sobbing by the end of the last show, including Jack Cassidy himself. His wife, Shirley Jones, and his young son, David Cassidy, were at the performance and I was shocked when Jack kissed me in front of everyone! We were all unbelievably emotional about that dear old show and about the family we had become.

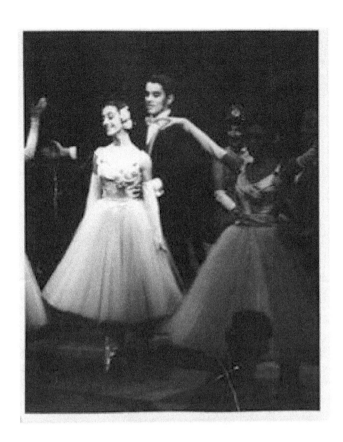

James DeBolt and Me in "The Merry Widow" Pas de Deux

 <u>The Merry Widow</u> was very difficult for the dancers: we had some twelve numbers, including a pas de deux for Jamie and me to music that Abba arranged from the Lehar score. Joyce was in a bad mood throughout the rehearsal period, making life hard for all of us. We later found out why: she was pregnant! Our stars were Larry Kert (<u>West Side Story</u>) and Kathryn Grayson (movies), both of whom were very nice, but not very suitable for their parts. Maybe they just didn't compare well to Beverly Sills and John Reardon of NYCO. I was surprised to see that Kathryn couldn't remember her part at all and had to write "crib sheets" on her handkerchiefs, her fans, her sleeves, her wrists, etc.

The show didn't go well, and we closed early, but everyone except Jamie and I transferred to one of the other shows on the circuit. As for Jamie and me, we were glad to get back to New York and the Joffrey.

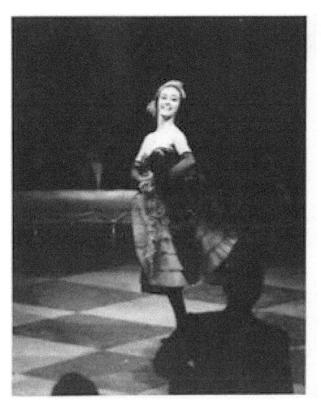

Can-Can in "The Merry Widow"

Our first day back was disappointing: Lee Becker Theodore (Anybodies in <u>West Side Story</u>) and Gloria Contreras (Mexico) watched class to cast the pieces they were going to choreograph for a Joffrey workshop performance. Gloria immediately eliminated Jamie! Then Bob dropped the next bomb – on me." You're not doing the opera season but, if I take anyone else, the next one will be you." What was I going to do for money? The next day, he reprimanded me for being a "pretty-pretty" dancer; the pianist had played Ravel's <u>La Valse</u>, and I had smiled. He also called me lazy in front of everyone. I did, however, sign my contract for the rehearsal period and the workshop.

I was cast in the corps of Gloria's piece, and understudied Mary Ellen's pas de deux. Gloria then took me out of the first Bagatelle because "it will take three hours to work out the movements for you!" Me – the fastest learner in the company! What on earth was going on? Her only correction to me? "That was very bad, Rochelle." (Remember this – it had later ramifications.) The next day

it was Lee's turn: she took me out of one section of her piece and insulted both Jamie and me. The day after that, in front of several visitors, she insulted me again. Only much later did Elisabeth Carroll tell me that Lee must have hated herself: she always picked on the dancer who most resembled her (it was Elisabeth in Ballet Theatre and me in the Joffrey); Lee was tiny and talented, and so were Elisabeth and I. The performance was in a studio at City Center. Lee was obviously nervous and made so many last minute changes that she was making us all nervous as well. Jamie and I asked questions about some of the changes; she called us stupid in front of the whole company. At least we celebrated afterward with a party at the apartment of Borden Stevenson (son of Adlai): high floor, overlooking St. Patrick's Cathedral, beautiful views, splendid furnishings.

I took off for a week in Elmira to stage Les Sylphides, which Jamie and I later went up and danced with Mme Halina's little company. When I got back, Bob asked me to set the dances in NYCO's Carmen. Since he had decided, after all, to use me in Aida, I was willing to rehearse the other operas for him. In fact, this time, I signed a soloist contract with the opera company because the one part I was doing, a Blackamoor in Aida, was a soloist role. Bob started working with Larry Rhodes and me. While we were rehearsing the piece, I continued to take classes at the school from Edward Caton (Russian, appeared with Ballet Theatre).

One day, Mr. Caton asked me to accompany him uptown to Bohemian Hall in order to demonstrate for a class that he was teaching there. Bob gave me permission and off we went. After the class, a short, bearded man came up to me and two other young women and asked if we had pointe shoes. Two of us did, and he thanked the third girl and asked her to leave. When we had put on our pointe shoes, he asked us to do some fouettés. After I'd finished, he thanked the other girl and told me to go to a studio downstairs. I saw someone I knew, Larry Gradus from Ballet Theatre, and asked him

"Where am I? What is this?"

"This is Jerry Robbins' company, Ballets: USA."

I immediately ran over to Mr. Caton:

"What have you done? I'm still with the Joffrey Ballet."

"Robert said it's all right, Rochelle, for you to do this. It will be very good for you."

Downstairs I went, where I met Francia Russell (NYCB), whom I knew from Bob's classes. She said she was injured and I was to understudy her in case she wasn't able to dance in their

upcoming Broadway season. She put on the music tape and started marking the first movement of Robbins' Interplay. When she'd finished, I said

"Okay, I've got it."

"How?"

"Trust me – I've got it."

"Do you mind if I see it?" So I danced it full out for her. She asked if I'd ever been in a company that performed it.

"No, but I've seen a few performances of it at Ballet Theatre."

She ran upstairs and came back with Howard Jeffries, the ballet master.

"Is there a problem? Can't she do it?"

Francia asked me to to do what I had learned for Howard.

"But you've only been here for about five minutes. How did she learn it so fast? Well, go on and teach her the rest and then bring her upstairs."

Fifteen minutes later, we were in the big studio upstairs. Robbins asked what the matter was.

"Nothing, Jerry. She's ready to do it."

"But the ballet is twenty minutes long, and you've only been down there about twenty minutes. All right, let's see it."

He put me into Francia's part and we ran the ballet.

"Okay, start teaching her The Cage."

That's how I came to do the last Broadway season, at the ANTA theater, of Jerome Robbins' Ballets: USA.

My schedule then got crazier and crazier. I was still rehearsing Aida as well as the Robbins ballets, in two different locations. Bob and Warren came to see the Robbins before I got into Interplay, so they only saw me in The Cage.

Bob: "Your feet look beautiful, but you must lose lots of weight."

Warren: "You look positively obese."

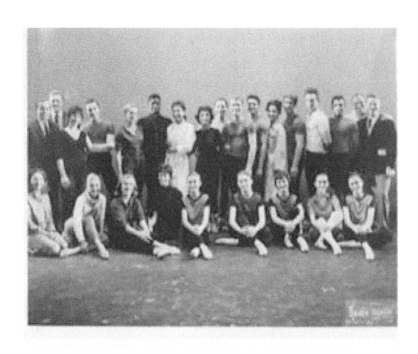

Ballets USA Company Photo, I am second to last on floor on right

(I still only weighed 90 pounds and, as you can see in the Robbins company photo, I looked like a skeleton. I think what happened is that Bob, who usually used binoculars at performances, confused me with another of the dancers, Charlene Mehl, who was about my height, did have beautiful feet and was rounder and more muscular than me.) I did, however, go back on the diet pills. Jeannot Cerrone, Robbins' general manager and a representative of Rebekah Harkness, who was funding the company, kept running into me as I worked on the empty stage of the theater every day. He always smiled and shook his head approvingly at how hard I was working. He really liked me, and I'm pretty sure he talked to Robbins about me, too.

One day I did a matinée of <u>Aida</u> at City Center, got into a taxi in blackface makeup, took it off in the cab (the cabbie said he'd never seen anything like that before, and he wouldn't accept any money from me!), arrived at the ANTA theater and danced Kay Mazzo's part in <u>Interplay</u> – not the one I'd learned, and one with a solo as well as the fouettés! Rehearsal? Well, we spent fifteen minutes before the show exchanging tunics – Robbins didn't want two of the same color next to each other in any of the diagonal lines, and mine was always wrong. So I went onstage – as usual – without having danced a step in Kay's place. It went well until the "grand right and left" circle. I was figuring that out as we were dancing, and I thought since Francia started with her right hand, and she was fourth in line, Kay must start with her left because she was first in line, not realizing

100

that everyone starts with their right. I led everyone around the stage and, when I got to the downstage right wing, there was Robbins, slapping his thigh and roaring with silent laughter, tears streaming from his eyes. Hmm… When the ballet was over, he stopped me on my way to the dressing room,

"If I had tried to choreograph it that way, I could never have done it. You have so much energy and enthusiasm and you started with the wrong arm and leg, and you left absolute chaos behind you! No one knew which hand to extend. But it didn't matter – I'm sure the audience was watching you anyway!" He wasn't even angry!

The ANTA season was wonderful for me: I eventually danced all the parts in Interplay – all, that is, except the one I'd learned from Francia. At the end of the season, Robbins gave a party for all of us at Sardi's restaurant. Several special things happened there. First of all, there was a drawing of Miss Hoctor on the wall and I showed her to everyone. Secondly, among the guests were Natalie Wood (she had just finished making the movie of West Side Story) and her then boyfriend, Warren Beatty. Thirdly, Leonard Bernstein asked me to dance with him! He was a wonderful dancer and, when I told him so, that handsome, tall Jewish man looked at me, a little Jewish girl, winked, and said,

"All God's children got rhythm!"

Sardi's reception, Geralyn Donald, James DeBolt, Me, Jeannot Cerrone, Susan Borrée

Fourth, when all the dancers were seated at a couple of large round tables, Robbins came over to thank us for doing so well. (Very different from Bob, who would sometimes yell into the dressing room, "I expect an apology from each of you for such a bad performance.") Fifth, Robbins went around and spoke to each of us quietly and privately. He told me, "You're marvelous onstage!" After he left, I said, "Well, I guess I'll be with you all a bit longer. Jerry just asked me to go on the tour." The others looked confused: it turned out he hadn't asked any of them yet! My Robbins experience wasn't quite over yet. There was an AGMA meeting at the Hotel Wellington, and he spoke articulately about the advantages of American companies touring abroad. A few days later, Mr. Caton told me, "Jerry is counting on you to go to Asia with the company next spring." Unfortunately, that never happened because the company folded in the middle of the US tour he'd invited me to go on. It disbanded because Jerry refused to take John Jones, a beautiful black dancer, out of a sensual duet with Wilma Curley, a white woman, in NY Export: Opus Jazz. Mind you, this was 1961, and our country was still having the same problems as we had when Raven Wilkinson was touring with the Ballet Russe.

At this time, Jamie auditioned for NYCB – and they took him! He was very conflicted about leaving the Joffrey – he'd known Bob since he was a young boy in Seattle – and his meeting with Bob was typical of the way Bob dealt with us. Jamie came out of that meeting in tears: all he wanted Bob to say was "I don't want you to go. I love your dancing and want you to stay in the company." What did Bob actually say? "It's a wonderful opportunity for you. I think you should do it." When I went into Bob's office next for my meeting with him, he was in tears as well. He really did love Jamie, but he just couldn't bring himself to say so. He replaced Jamie with the young Helgi Tomasson, who told me he liked me best as a dancer of all the girls in the company!

Next news: since my nemesis had left the company after only one year, Larry Rhodes had no partner for the pas de deux from Flower Festival in Genzano. Who did Bob choose to do it? Not me, but Brunie. And Rita, who in no way would ever be technically strong enough to do it, was second cast! It really seemed as though Bob was trying to ease me out of the company, at least as a dancer. Meanwhile, people outside the company were offering me jobs. For instance, Joyce Trisler asked if I would be interested in being her assistant choreographer for an off-Broadway show. Unfortunately, that didn't happen.

I also got a phone call at the studio asking if I could do one of the students a huge favor: Richard Nicklaus was presenting a joint concert with Gloria Contreras of their choreography, and

Helen Kane, who was to dance his pas de deux – the next day, of course – had sprained her ankle and couldn't do it. Would I learn her part? Bob gave me permission to do it, so I ran off to Bohemian Hall to learn the pas de deux with Thomas Enckel. First problem: Thomas and Helen were both very tall, so all the lifts that had taken a long time to devolve were now being done very quickly as my short body took so much less time to slide into and out of them. Second problem: the music was a very beautiful piece by Henry Brandt, a contemporary composer, but I had never heard it before and it was difficult. I asked Richard not to try to teach it to me musically – just the steps, please – and I would take home the music cassette and do my best to fit the steps to it by myself overnight. The next day, we did the concert, the duet was very successful, and Gloria Contreras grabbed me afterward. "What did Bob mean that I would be disappointed in you as a performer? And that you were a slow learner? Why did he tell me not to use you? I don't understand." So that's what had happened in the workshop rehearsals. Gloria then asked me to do more of her concerts and I was happy to do them because I really liked her choreography, and this time we had a good working relationship.

Since I was disheartened about my relationship with Bob, and since Jamie had joined NYCB, I decided to audition for Mr. Balanchine. Janet Reed (NYCB ballet mistress, former principal dancer) and Violette Verdy (principal dancer NYCB) both spoke to him about me, and it was arranged that I should take company class, which Mr. Balanchine would watch, and then I should be prepared to dance something for him. I took Janet's class, but he didn't appear. When he arrived, she introduced me to him and reminded him that he had agreed to look at me. He eyed me up and down and said, "I must rehearse now. (He was choreographing A Midsummer Night's Dream.) Wait until lunch and I will see you then." Meanwhile, Eddy Villella asked me what I was doing there. When I told him I was auditioning, he said,

"What are you going to dance?"

"I've done Pas de Dix, so, I thought I'd do the ballerina solo from that."

"Mr. B is always looking for someone who can dance the third movement of Bizet (Symphony in C) because it's so hard. Why don't you and I go into the other studio and I'll teach it to you? We can do it together for him."

Actually, I already knew it from having seen performances of the ballet, but we went over it anyway. Mr. B had told me I could watch rehearsals. I was rather upset by the way he was treating Melissa Hayden – he was very insulting to her, and in front of the children who were playing the

butterflies, too. When he'd finished the rehearsal, he walked by me and said, "I go to eat lunch now. I see you when I come back." Good, a little more time for me to warm up and practice.

When he came back, he told me to stand by the piano while he did some more rehearsing. Three hours later, as he passed me on his way out, he said,

"Why you don't come back when we need cygnets in Swan Lake, maybe?"

"Mr. Balanchine, I've heard so much about you, but nobody ever told me how

rude you are."

As he left, Jamie said, "You'll never get into the company now."

"Why would I want to? If he treats people like that? And like he did with Millie in rehearsal? No, thank you."

End of NYCB and me.

A week later, I had my conference with Bob, and he was horrible to me: he coldly excoriated me about my body, my weight, my feet, my sincerity, my attitude, my work habits, my sloth, etc. All I could say was, "This isn't true." Was it all guilt about Flower Festival? I brought him a list of all my classes and rehearsal hours for the past three months, but he was sarcastic again as if he didn't believe me. The worst thing was that Jamie was angry with me for taking all that abuse, but what could I do? Where could I go? I felt I needed to stay because I still had more to learn from Bob. When Bea heard what had happened, she said, "Bob is a sick, sick boy."

The next day in class, Bob had me demonstrate two combinations and said "good" to me! With Ninette de Valois watching, he turned the class over to me when he escorted her out. Go figure.

Rehearsals began for the next tour: Fille again with Gerry. I had more rehearsals on that ballet after I'd performed it than before I had! This time, Mama was to be played by John Wilson en travestie, quite a different feeling from working with a woman, but his sense of humor made it less difficult than I thought it would be. Lone Isakssen was new in the company and, at long last, Bob let me teach Lisette to her so that I would have someone to alternate with. I rehearsed for hours with her alone, with Gerry, with Gerry and John, sometimes as many as seven hours a day. But Lone, lovely as she was, had so many excuses. "I have pains. I'm so tired. This is too hard for me." To my knowledge, although I prepared her as well as it was possible to do, she never danced the whole ballet, never performed it at all. I was hoping that, if I didn't have to do every performance, I could learn new repertory without Bob always saying, "Well, you have Fille." In fact, after one

especially grueling day, he took me aside and said, "You've been a good girl lately, so I want you to learn Flower Festival. Learn it well. You're not going to dance it, but I want you to learn it." I always wanted to learn everything, but really!

We were also going to do Balanchine's Square Dance. Una Kai had been working very hard trying to reconstruct it because it had been out of the NYCB repertory for years. She brought several NYCB dancers to our studio to help her with it, and taught it to Gerry and the six corps de ballet couples – no ballerina. Why? Brunie, Françoise, Marie and Diane refused to do it, and he wouldn't let me learn it – sound familiar? Meanwhile we continued to work on Fille and Con Amore, and Miss Moore dragged me into Flower Festival rehearsals after I said no.

"It isn't fair. I never had a chance to learn it and work on it with Fredbjorn and, as a result, I won't be able to do it as well as I know I could. I need coaching as much as anyone else in the company does, and I never get it."

"I asked for you, I want you to do it. Freddie would want you to do it, too."

So I learned it with her and Larry and worked on it on my own as usual. That's how 1961 came to an end.

Act Two, Scene Three

Still the Robert Joffrey Ballet

No More Dancing for Joffrey

1962 began the way 1961 finished, in the middle of a rehearsal period. I was still doing the corps of <u>Con Amore</u>, which we were rehearsing for the new people, and I was doing my best to get Lone into <u>Fille</u>. We had a one hour rehearsal scheduled for <u>Flower Festival</u> one day when the explosion occurred: since I was third cast, Lillian had just gotten to me when I was scheduled for another rehearsal (to work with Lone again). Bob wouldn't let me finish the pas de deux, but he yelled at me, insisting I leave immediately, embarrassing Lillian as well as frustrating me. He also angered Helgi by arbitrarily changing his name to Harold in the souvenir program "because it's more American than Helgi, and we're an American company".

When we started <u>Square Dance</u>, I was assigned to understudy Lone in the corps: although Gerry was already working on the male lead, Bob still hadn't cast a female lead, and Una was getting nervous about that. Ten days into the rehearsal period, she asked me to help her out by learning the role: she'd gotten to a point where she really needed all the dancers in order to finish the ballet, and I, at least, was a body in space for her. So, in secret, I started working on it with Gerry. When Bob heard what we were doing, he was quite clear that I could help out, but I would definitely not be dancing it. Period. This was the original version of the ballet, which included an onstage chamber orchestra and Elisha Keeler, a wonderful professional square dance caller, who came to watch rehearsal one day. He had to begin writing and practicing his script soon, and that was going to be difficult without a leading dancer to hang his lyrics on (Chellie, jelly, belly, etc.)

Joffrey Ballet Souvenir Program

Bob hired Ra Cantu to take company photographs for the souvenir program book, and we had individual sessions at his studio. When my session conflicted with rehearsals at the old Phoenix Theater, Bob told me to miss class and get there as soon as I could. When I reached the theater, I didn't know where the dressing rooms were. Larry was onstage, and I asked him where I should go.

"Can I help you, Miss"?

"Larry, it's me, Chellie".

He didn't recognize me with my Ra Cantu makeup! We were scheduled to run our whole tour repertoire so that Bob (and his guests) could have a clearer view of what needed to be done than could be seen in our small studio. We did <u>Raymonda, Partita, Pastorale, Pas des Déesses, Ropes, Con Amore</u> and <u>Flower Festival</u>. I was completely shocked to be asked to do the last, but I guess it would really have been too much for Brunie to do that, as well as everything else she was doing (five ballets). Note that there was no <u>Square Dance</u>. Also note that with Lone possibly doing some

performances of <u>Fille</u>, I might be reduced to only dancing the corps de ballet of <u>Con Amore</u> some nights on the tour – and this too in my fourth year in the company! Among the guests were Rebekah Harkness and Gian Carlo Menotti.

The next day we had a publicity shoot – a "makeover" day at Helena Rubenstein's Fifth Avenue salon for all the girls. Even though I got there early, they kept taking the others ahead of me. Of course, I immediately assumed they wanted to delay me until the photographers were gone – I just wasn't pretty enough. Wrong! The Elizabeth Taylor movie, <u>Cleopatra</u>, had just opened, and the makeup expert decided that my features would lend themselves to that kind of exotic makeup, so he plucked my eyebrows (they never really grew back properly) and made me a very glamorous – and beautiful – Egyptian queen. One photographer asked me if I'd ever thought of being a model, but when I stood up and he saw how short I was, that conversation ended. He did mention something about modeling jewelry, however, but I wasn't really interested. Unfortunately, because I was the last one, I missed having my hair styled. We also had photos done "exercising", and the company got a spread in the New York Times out of it; so, I guess it was worth adding to our already heavy load. When we finished, we had to run to the Phoenix to do <u>Con Amore</u> and <u>Fille</u> with orchestra. Erik Bruhn was there, and I was pleased that he complimented my performance and even remembered my name!

Highlights of this, my last Joffrey dancing tour: two days after it began, my worst fear was realized: I only danced <u>Con Amore</u>. Talk about being depressed! It was a very long trip – we left at 8 a.m. and arrived at 7 p.m. No time for dinner, so John Wilson brought sandwiches to the theater for all of us. We had barre in a frigid dressing room because they had to sand the highly – and beautifully, thank you – waxed stage. In Louisville, the stage was big, and soft but treacherously slick in spots, splintery and full of holes. It really chewed up our pointe shoes.

In Kansas City, Una decided that she hadn't done all that work trying to put <u>Square Dance</u> together for nothing. She also knew about our history, with Miss Moore's pas de trois and Erik's <u>Duet</u>, of learning ballets but never performing them; so, she took Gerry, Jonathan, and me to a local dance studio and square danced us nearly to death. She then called Bob in New York and asked him to send us costumes. He sent them all right: six blue leotards for the girls, six blue T-shirts for the boys, a white T-shirt for Gerry, and two size 16 MEN'S leotards for me! Una then told us to wear our "uniforms" (which we used for lectures and demonstrations) until we got to

109

Los Angeles, where she could buy me my white CHILDREN'S size leotards. I think she was as angry as I was! We premiered Square Dance in Borger, TX.

From Albuquerque, NM, we flew to Los Angeles where Una bought the leotards for me so we could finally dance Square Dance in costume. I received a package there from my mother containing four new size-five dresses – and I had to alter them because they were too big! I also caught a bad cold there and woke up the morning of our matinée performance with a fever of 102°; so, Suzanne (with a soft corn between her toes) and I headed to the emergency room of the nearest hospital where a doctor worked on her foot, and another one gave me a penicillin shot and told me to go to bed for the next 24 hours. When I told him I was dancing that afternoon, he said, "This I have to see"! We did Square Dance, and I was so dizzy I actually missed an entrance. The next day when I tried to get on the bus for Burbank, Bob sent me back to the hotel with instructions to stay in bed as long as possible. A friend of mine drove me to the theater, where I danced only in Con Amore – I don't know how because I felt so awful. The next night was John's first Mama Simone with me in Fille, and the night after that was another Square Dance.

In Hollywood, Bobbie Craig, my old Ballet Russe roommate, invited me and Helgi to Century Fox Studios, where she was shooting Follow the Sun, a television show. We had lunch with her, Cesar Romero, Elsa Lanchester, Jayne Mansfield, and Mickey Hargitay (all movie stars). It was strange: there were three companies performing in Los Angeles at the same time: Ballet Theatre was at the tiny Biltmore Theater, Ballet Russe was at the slightly larger Philharmonic, and our little Joffrey Ballet was at the enormous Shrine Auditorium. It was so big it could hold three high school graduations simultaneously on its cavernous stage. We were all exhausted by the end of the performance from all the extra running we had to do on exits and entrances.

In Manhattan Beach, still very ill, I fell in Square Dance, and Gerry, instead of helping me up, let me lie there while he improvised a solo around me! Bob came backstage, raging at me. He didn't ask if I'd hurt myself but said: "It's bravura dancing, and you don't do it that way. Do you know it's supposed to be bravura? You never rehearse the pas de deux (not true!). Maybe we should just stop doing the ballet". The reason he was so furious was that Dance Magazine had critics in the audience that night. When the publication came out, I got a great review from them – he couldn't have been too happy about that after all his hysterics.

The next day, I was scheduled for an hour's rehearsal on Fille with Jonathan and a whole 15 minutes with Gerry on both Fille and Square Dance before performing with a fever again and

110

strange spots in my eyes (these will come up later). We had a free day in Hollywood, and I had dinner with Bobbie and Jerry Goldsmith, the composer of the musical score for <u>Planet of the Apes,</u> among other movies. I still had a fever, and didn't feel like eating at all, and because I was perspiring so much, Suzanne and I were changing my sheets several times a night.

In Reno, NV, many of the dancers, plus Bob, went to the hotel's casino. They said it was hysterical: every time you won on the slot machines, a bell would ring, and all night long, all you could hear was the bell and Bob calling, "I won! I won!" The next day he got onto the bus with a huge sack of nickels, $85 worth, from his winnings. Gerry won $40, Larry lost $15, and Vicente was the big loser of $85, the same amount Bob had won.

One night, Una wouldn't let me perform. She actually put on her pointe shoes and somehow got into my costume (she was a lot taller than me) and danced <u>Con Amore</u> so that I could stay at the hotel and rest. The next night, when I got to the theater, I looked at myself in the dressing room mirror and wondered, "Where are my hips"? They'd disappeared along with a lot of the rest of me. After weighing myself, I stood in the doorway of Bob's dressing room.

"Well, I've done it. I'm 87 pounds".

"You look wonderful"!

"Here's the deal. I can stand here and weigh 87 pounds, or I can gain some weight and dance. You can't have it both ways".

"Don't gain an ounce"!

Whether he liked it or not, I did gain a few pounds and danced. In Chico, CA, we rehearsed <u>Square Dance</u> before the performance but it went badly that night. (I wrote in my diary "Gerry is the WORST partner"!) The next night, Gerry was unbelievable: he blamed me and yelled at me in front of Una and Suzanne, and he was WRONG! It went better that night, and when I got on the bus I said to Bob,

"It was better tonight, yes"? Nothing. "A little"?

"Not <u>much</u> better".

In Salem, OR we were scheduled for a free night, but getting there turned out to be an adventure. We left at 9 a.m., but by noon had only managed 22 miles: snow, ice, putting chains on the tires, road blocks. Finally, on the bus, Bob broke out about ten bottles of champagne, and we all got drunk and somehow didn't mind the delay at all.

In Seattle, Bob's hometown, he was, as usual, nervous and nasty. Fortunately, Square Dance went well. In Walla Walla, we were invited to a Russian Easter buffet given by Bob's first ballet teacher, Ivan Novikoff. And I wore a size 3 dress to the party! By then I was starting to get leg cramps from doing Square Dance every night. Later, Patricia Wilde (ballerina of NYCB who had originated the role), told me she couldn't dance it more than once every ten days, and she had someone massage her legs during every performance, and she was dancing on the same stage and on a non-skid floor. We were on the bus every day, dancing every night on different-sized, mostly hard stages – and they were slippery, too! Then things got worse: Françoise's ankles were bad, so I danced both Fille and Square Dance on the same program several times, a really heavy load.

After passing through beautiful scenery on the way to Denver, I stayed at Suzanne's house. Square Dance went well, but it was hard in that altitude. We had oxygen masks backstage and Gerry and I took turns grabbing the masks from each other, using them in the wings. The only one who fainted – and she was from there - was Suzanne! In North Platte, Ballet Theatre spent the night in the same hotel as we did, and I had dinner with Lucia Chase, their director! In DeKalb, IL, Bob brought all us girls red scarves to wear around our buns in Square Dance. He also gave me some constructive criticism on it for the first time. We did it last that night, and the audience was so warm and so ready for it that it went really well. Bob was very pleased and took special care to call into the dressing room.

"Rochelle, very good"!

Diane called out to him, "Great company you have here, Bob. You finally give someone a compliment, and she breaks down and cries."

Because that's exactly what I'd done.

When the last casting sheet came out, and I was not scheduled for Flower Festival, I made up my mind that I had no future in the company. It was time to think about leaving. But, typically, the very next day before Una's class Bob told me I might be doing it that very night. I left class before the jumps and Bob met me backstage.

"Why did you leave class"?

"In case I have to do both Square Dance and Flower Festival because they're both so hard on my legs".

"I haven't decided yet, so go back and finish."

112

Furious, I turned on my heel and went to my dressing room. When class was over, I was called onstage to rehearse Flower because Larry and I were dancing it that night! It seems that Bob had promised Larry that he could dance it in Detroit, his hometown, but who would be willing to do it with him on such short notice? Who do you think? So, I danced Square Dance, Flower Festival, and, by the way, Con Amore as well for the next several performances.

In Indianapolis, Margaret Saul (my old Cecchetti teacher from Boston, who had said she couldn't imagine what kind of professional company would take me) came backstage. She entered the dressing room.

"Why, hello, Miss Saul. How nice to see you! What are you doing here?"

"I live and teach here now. Stretch out your leg for me, please. Well, I do believe you've got your knees straight after all!"

And she left – without another word! Brunie asked, "Who was that [masked] woman?"

Larry and I got a very good review for Flower Festival in Detroit, but there was some not-so-good news there as well. Jeannot Cerrone and Bob announced that we would not be going to Spoleto, as had been rumored, but would instead be doing a workshop in Watch Hill, RI, sponsored by Rebekah Harkness. Mrs. Harkness and Jerry Robbins had parted ways because he wouldn't give up control of his company to her, a cautionary tale that Bob should have paid attention to. That about did it for me: I'd been so looking forward to a trip to Europe to make up for all the grief I kept getting from Bob, and now it wasn't going to happen. Bob must have sensed that I was really on the edge because he was quite complimentary about my last performances of the tour. As it turns out, they were my last performances as a dancer in the Joffrey Ballet.

Back to New York and, yes, Unemployment again. In Bea's class I fell and twisted my ankle doing – of all things – a gargouillade, the jump that is the theme step of Square Dance! I'd only done hundreds of them on the tour. We were all invited to a posh cocktail party at Mrs. Harkness' suite at the Westbury Hotel. I got there early and was introduced, as someone who loved music, by Mrs. Harkness' husband, Dr. Keane, to a nice man named Sam. While we were talking, I realized that "Sam" was Samuel Barber, one of America's greatest composers (and one of Rebekah's composition teachers)!

I was exhausted, and my legs and feet were giving me fits – all that jumping – so, when my parents invited me to go to Miami Beach for a vacation with them, I got permission from Bob to

go, asked him to call me when he needed me, and I went. While there, I learned how to dive, swam every day, got the first sun tan of my life and took daily classes (minus the jumps) from Thomas Armour, who had danced with the Diaghilev Ballets Russes and with Ida Rubenstein's company in Paris. Meanwhile, I kept trying to reach Bob to find out when he wanted me back in New York, but he wouldn't take my calls. When I finally did get through to him, it was to find out that he wasn't going to take me to Seattle, where the company was to dance Aida at the World's Fair. Needless to say, I was not happy.

When I got back to New York, I started having treatments on my strained arches and had a long talk with John Wilson, who was also very depressed about Bob and the direction the company was going in. I also spent time with Violette (Ballet Theatre and NYCB ballerina) and Mama Verdy as they tried to give me some advice about my future. Their decision: go to Europe. They were sure that Marie Rambert would take me into her company. I told Bea I was leaving the company, and she thought it was the right thing for me to do, but when I told Miss Moore, she definitely advised me to stay. I also turned down an offer as ballerina of the Royal Winnipeg Ballet. You can see how conflicted I was – and how stupid!

When Bob got back from Seattle, he "hadn't decided" if he was going to take me to Watch Hill – Jacob's Pillow all over again. I finally signed my contract the day before we left, after he had discussed the "conditions" of my going: I had to work harder (give me a break!); I had to lose weight; I had to be more humble (?); I had to improve my "attitude" (what on earth did that mean?); etc. My mother must have been right: he really didn't want people to think I was the type of dancer he wanted in the company. Or was it just that I was too strong emotionally for him? He certainly did his best to try to break me, but it didn't work.

When we got to Watch Hill, the studio wasn't quite finished; so, we had a few days of beach time and play time. My roommates and I had an apartment right next to the firehouse/studio; so, I spent a lot of time working on my own, either doing barre or practicing on pointe. Larry Rhodes and I worked on Raymonda, and I practiced the piano as well. It seemed as if every time Bob brought visitors to the studio to show off the beautiful new facility, I was there, all alone, working on one thing or another. He finally was able to give us a hard two hour class, after which he told me I was working very well and that he was going to raise my salary to $95 a week – I can't imagine what it was before that.

Donald Saddler (Ballet Theatre and Broadway) arrived that day to audition us for a new piece he was going to choreograph for the company. Now Bob always claimed that choreographers had free rein to choose their casts, that he, Bob, didn't try to influence them in any way. I already knew how untrue that was from my own experience (Peggy van Praag, Dirk Sanders, Gloria Contreras, Vida Brown, Una Kai, Fredbjorn Bjornsson, etc.), but this time it was almost funny. Don taught us a theme step, asked us to improvise the rest and took us in groups of three. In the first group, he asked Lone Isaacson, "Are you Lisa (the former Rita)?" "No." In the second group it was me. "Are you Lisa?" "No." In the third group (which contained Lisa), he asked Elisabeth Carroll, "Are you Lisa?" "No." He never found Lisa at that audition but guess who wound up doing the lead in his ballet? Lisa, of course! Five of us were free from rehearsal that day, so we went for a long walk and visited the B-shaped swimming pool at Rebekah's gloomy McMansion.

The next day, when Bob gave fouettés during class, he suddenly made me stop.

"Why?"

"Didn't you see that Françoise was traveling? She almost bumped into you!"

Not only had I not seen her, I realized I wasn't seeing him very clearly either. Dr. Keane immediately asked Jeannot to drive me to an ophthalmologist and, unbeknownst to me, he had Una and my roommates pack my belongings into my bags. He obviously knew what was wrong, even if I didn't. It was those spots in my eyes, which had gotten worse. Jeannot dropped me off. He said, "Don't worry. I'm sure you just have something in your eye, and you're going to be all right. I have to pick someone up at the train station and then I'll be back to get you."

Dr. Kaplan was very nice, but his exam was difficult and painful and his words were grim.

"I'm sending you to Boston."

"Oh, that's where my family lives."

"Good. I've made an appointment for you at Massachusetts Eye and Ear Hospital. I'm putting a patch over your right eye and another one, with a little pinhole in it, over the left one. Leave them on. Turn your head if you want to see something. Try not to move your eyes. You have a detached retina, and you're going to need surgery."

When Jeannot came back, Alvin Ailey was in the car with him. Both of them were shocked to see me with the patches on. I told them what Dr. Kaplan had said. Alvin: "But you can't leave! I'm doing a piece for the company with you as the lead." (That was Feast of Ashes, and I was really

upset not to be able to dance it.) When we got back to Watch Hill, Bob was in my room. He kissed me and told me not to worry, that everything would be all right. "Go and say goodbye to your friends." I assumed he had told them what had happened to me. Wrong! When I got to the studio, I heard a collective gasp from the dancers as they saw my masked face. Jeannot drove Una and me to the train station in Westerly, and she and I traveled to Boston and an uncertain future for me. Thank heavens she was with me, as we got along well and I didn't have to face what was happening to me by myself.

The next three weeks were a blur. I had painful exams at Retina Associates, waited for the results, and was admitted for surgery on my right eye (the worse one). Dr. Regan put a plastic buckle around the inside of my eye and attached the retina to it. It took eight hours. The anesthesia made me violently ill for about 24 hours. When that was over, it turned out that the surgery hadn't been entirely successful and I had to stay in bed on a 45° angle for a week. After that, I had the surgery on my left eye. Again the violent reaction to anesthesia, but this time the surgery went all right. Every time I moaned, my dad made the doctor give me more pain medication until I woke up enough to say, "Stop! I'd rather have the pain than be sedated like a zombie." One of the Boston Ballet's young dancers came to visit me.

"With this new injury, do you know what they're calling you now?"

"No."

"The Living Legend!"

My Jamie (we were engaged by then) took a week off from NYCB to spend as much time with me as he could. What glorious plans we made for a wedding that was never going to happen.

I spent the summer and fall in Boston with my parents, trying to keep my spirits up. At the end of the Watch Hill rehearsal period, the company did a little demonstration in the firehouse of what they had accomplished. My dad drove me down to see it. Gerry, having hurt his back dancing at the Seattle World's Fair, wasn't dancing either. We stood next to each other in the doorway of the studio watching all the ballets that had been choreographed that summer. I was okay until the dancers did some excerpts from a character dance class taught by Yurek Lazowski. That did it for me: remembering how much I'd always loved that kind of dancing, I broke down. Dear Gerry led me on a brisk walk on the lawn, supporting me both physically and emotionally: "Chellie, you and I should both be in there, since both of us love to dance so much. I may never be able to get back

onstage, but you will. I know you will. Your career still has a long way to go before it's over."
Bless him, the dear boy.

Just before Thanksgiving, I explained the floor barre to my doctors and asked them when I could do it. They said I could begin on the first of December. They also said they expected me to dance again. If my retinas did detach again, they would be able to fix them, but then I'd know that my performing career was over. I worked on the exercises every day, stood up for my first class on the first of January, and moved back to New York on the first of February, prepared to dance with the Joffrey, but that wasn't to be.

Act Three

Have Tutu, Will Travel

Still Dancing, but Not for Joffrey

As my recovery progressed, and as I was still at home in Boston, I decided to try some college courses. Since I still didn't have a high school diploma, I had to audit them, but that was all right. The two I chose were a class in opera and music drama at Boston University and one in the Russian language at Harvard University. I quit the one at B.U. after a few classes when the teacher, presenting Claudio Monteverdi to us, said that none of his operas had ever been performed in the United States. When I raised my hand to say that I had danced in his <u>Orfeo</u> at the New York City Opera, she said, "Oh, I mean by a professional company – the Met." That did it for me! I loved the Russian and did so well in it that several of the (adult) students asked me to work with them on it but, between eye doctor appointments that left me not able to see, my dad's having to drive me to every class, and occasional trips to New York for Workmen's Compensation hearings, I finally gave that up, too. I was, however, at last learning to speak Russian.

On one of my New York trips, I saw the Joffrey Ballet at the Fashion Institute, performing excerpts from the new ballets they had learned at Watch Hill: <u>Roundabout</u> (Fernand Nault); <u>Incubus</u> and <u>Undine</u> – later called <u>Sea Shadow</u> (Gerald Arpino); <u>Dreams of Glory</u> (Donald Saddler); <u>Feast of Ashes</u> (Alvin Ailey); <u>Time Out of Mind</u> (Brian MacDonald); and Bob Joffrey's beautiful <u>Gamelan</u>. It was very hard for me to sit in the audience – and not be onstage – for those performances.

While in New York, I took some classes at Ballet Theatre School. I also had an appointment with the Workmen's Compensation doctor, and it was awful: they can be so insensitive sometimes. He said,

"What are you going to do with the rest of your life?"

"I'm going to dance again as soon as I can."

"Oh, no – if you dance again you'll be blind in six months!" There I was, 24 years old, alone in New York, and he'd just told me my life was over. I was suicidal – after all, all I'd ever wanted to do was dance – so, of course, I went to class. Bill Griffith gave pirouettes, of course, but I only did singles – without spotting (the ultra-fast spinning of the head). He kept insisting that I do more (I had told him before class what the doctor had said), but I was so scared. Erik Bruhn was in class and he took me aside and said, "Chellie, look at me, spot on me. What is the worst that can happen?

Your doctors told you they can fix your eyes again, and you know you can't dance without spotting." Bless both of them – I left that class knowing I'd be dancing again soon.

Back to Boston, where my dad was shocked to hear me curse for the first time. It happened when the Bell Telephone Hour on TV presented Erik Bruhn and Carla Fracci in La Sylphide – and the Cuban Missile Crisis had the temerity to intervene. And the only thing the network cut was Erik's variation – to keep repeating that there was nothing new to report!

While I was still home, Gerry phoned to ask me if I would rehearse the company in La Fille Mal Gardée, so I went back to New York again. They were working at Bohemian Hall on Raymonda and Con Amore as well, and I rehearsed two couples in the leads for Fille, expecting Bob to talk to me about coming back to dance. He never did, and the company went off to Afghanistan and India without me.

"Don Quixote" Pas de Deux, Ballet Spectaculars

Meanwhile, Ramon Segarra, a dancer with the New York City Ballet, asked me to dance three pas de deux with him and a symphony orchestra in Miami on a program called Ballet Spectaculars. We started rehearsals immediately on pas de deux from Don Quixote, The Sleeping Beauty (Blue

120

Bird) and Les Deux, the last choreographed on us by Bobby Rodham, also from NYCB. Thus began Have Tutu, Will Travel, as we were among the first dancers to freelance with different companies and orchestras around the country. Jamie designed our costumes, and they were beautiful. Irina Borowska's mother made my Don Quixote tutu as a gift for my having taught Irina (ballerina of Ballet Russe) the pas de deux from Flower Festival so that she could dance it with London Festival Ballet.

High School of Performing Arts, "Blue Bird" Pas de Deux

Ray and I worked for a month on the pas de deux and finally decided we were ready to show them, so he arranged for us to perform them, in practice clothes, at the High School of Performing Arts, from which he had graduated. I still wasn't seeing all that well and had to be led on and off the stage, but we'd included that in our rehearsals. The little performance went well, and it felt so good to be back onstage again. Next, we met with the conductor, Dean Ryan, to discuss tempi, had lots of costume fittings, made a huge, round fiberboard box in which to carry the tutus, and continued rehearsing. My life was filled with classes, rehearsals, and costume fittings. We flew to

Miami, with the other passengers gaping at the enormous, and cumbersome, black tutu box that we lugged onto the plane, afraid that someone might steal it if we checked it.

The first stage rehearsal was a disaster for us: the other couples (Melissa Hayden and Jacques D'Amboise - NYCB Principals, and Marina Svetlova and George Zoritch from the Ballet Russe) took so much time that Ray and I only got to do Les Deux. Besides that, my Bluebird costume, beautiful as it was, didn't work at all. (I spent all night long sewing, sewing, sewing.) The next day, Jacques spoke to Ray:

"Where did you find this girl? She's not good enough. You had your choice of NYCB dancers – why her?"

During our performance of Bluebird, I heard Melissa speaking loudly backstage:

"Jacques, you have to come and watch this. That girl is marvelous!"

After we finished the performances, Jacques asked Ray to exchange airplane seats with him so that he could talk to me. He wanted me to audition for NYCB!!

Other things were happening for me at the same time: I was still on Unemployment every week; I was going to Compensation hearings about the leg I'd hurt in the Ballet Russe; I was till having trouble with my eyes and was seeing various doctors about that; I was elected to the Board of Governors of AGMA (our union): and the dance critic of the New York Herald Tribune, Walter Terry, called to ask if I wanted to audition for a small company he was putting together called America Dances, so I auditioned for him, Todd Bolender of NYCB and Norman Walker, a modern dancer whose company was to be a part of the group. Mr. Terry said it would only be corps de ballet work, but I was so grateful to be back on stage I didn't care what rank it was going to be. As I waited to hear the results of my audition, Mr. Terry called to say that I would NOT be doing any corps work, that I would be dancing Melissa Hayden's leading part in Todd Bolender's beautiful ballet, The Still Point, a spoof of Harriet Hoctor (actually Marilyn Miller of the Ziegfeld Follies), and the finale of the show, the Tommy Andrew waltz from his Invitations. Most exciting of all, our Mistress of Ceremonies was to be Ruth St. Denis, one of the three women who were the creators of modern dance in the world. Rehearsals began immediately. Todd taught The Still Point from back-to-front, so I didn't really understand it until we put the whole ballet together. Then I loved it.

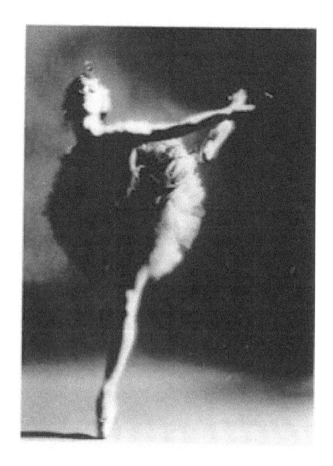

Bluebird

Saul Goodman, a writer for Dance Magazine, called to tell me I was going to be the "Dancer of the Month" in Dance Magazine! That entailed an interview and a photo session with Zachary Freyman, one of the very best dance photographers. I was so excited and so honored to have been chosen. I had to borrow a costume for the photos because I was told Freyman didn't like tutus, so I journeyed to the Joffrey and borrowed one. Guess whose costume was the only one that fit me? Lisa Bradley's – Bob's ideal-bodied dancer! As it turned out, Zachary loved Jamie's Bluebird tutu, so that's what I wore.

I remained busy, as Tommy was choreographing for the Philadelphia Lyric Opera; we were learning The Pearl Fishers. That meant rehearsing in New York, the bus to Philadelphia twice, "Texas dirt", a body make-up to enrich our color, and a fun performance. Oh, and Unemployment as well, and I was elected union representative of America Dances – I guess I didn't have enough to do!

Next came the tour of America Dances – more <u>Have Tutu, Will Travel</u> for all of us. The tour lasted five weeks and took us to Wilkes-Barre, Philadelphia, Baltimore, Washington, University Park PA, Morgantown, Richmond, Cleveland, Chicago, East Lansing, Cincinnati, Oxford OH, Bloomington, Lafayette IN, Memphis, Ruston LA, Lafayette LA, Pensacola, Tampa, Macon, Atlanta, and Sumter SC. Natalie Krassovska was the ballerina of the company, but when she left for a few days for another engagement in Dallas, Violette Verdy arrived to take her place. That meant shuffling roles: I now did the Prelude from <u>Les Sylphides</u> instead of <u>Glowworm,</u> and the <u>Don Quixote</u> pas de deux instead of <u>The Still Point</u>. Todd loved my version of the pas de deux – he said he'd never enjoyed it so much. I said the music and the choreography were Russian, so how Spanish was it really? Besides, since I was so much smaller than Tommy, I put 3 roses on top of my head in a tower to try to make up the difference in our heights. You had to know I was having fun with the excerpt once you saw that!

Ruth St. Denis caught pneumonia before the tour and, being ninety years old, she was never able to join us. Instead, Mr. Terry engaged Mme Danilova as our Mistress of Ceremonies. This was a problem because of her Russian accent, which left audiences, especially in the deep south, shaking their heads and trying to decipher what she had just said. Strangely, she was able to order "ham and eggs" for breakfast with no discernible accent at all! She was very nervous for the first few performances - she had never done anything like this before – but she soon warmed up to her role and became a real member of our little troupe. She did not remember me from the <u>Nutcracker</u> and <u>Coppélia</u> she had staged for the younger me in Boston, but she decided to help me, to "improve" me on this tour, so we worked on the bus before, during, and after class and backstage between pieces. My calves were killing me by the end of the tour!

The day after the tour ended, I was on my way, with Mr. Terry, Tommy, and Jess Meeker (Ted Shawn's formidable accompanist) and tutu box in hand, to Richmond, VA, to do a lecture/demonstration which would later turn into a TV program. They took my tutu box back to New York while I went on vacation to Florida with my parents. A few days after I got back to New York, I was called by the Ballet Mistress of Radio City Music Hall and asked to come and audition for a solo role in their next production! I duly went down there at an ungodly early hour and auditioned with Conrad Ludlow (NYCB Principal). Lunch and back for a rehearsal, which went extremely well. Much to my shock, Marc Platt (Choreographer/Director) thanked me and said he'd decided to use Judy Panzer instead. (She was already in their corps de ballet.) Conrad was as

stunned as I was, but he later found out that they only had to pay Judy a few dollars more to do the solo than she was already making, and they would have had to pay me a full soloist salary. That I understood, even if I thought it was the wrong thing to do artistically.

At an AGMA party for all the dancers in New York, Mme Danilova introduced me to Annette Page and Anya Linden (ballerinas of the Royal Ballet) as "our young American ballerina." I was so proud! There was also an AGMA Board of Governors meeting at which one of the topics to be discussed was the Joffrey Agreement at Watch Hill. There was also a posh party given by Mrs. Harkness for the Royal Ballet and "her" Joffrey Ballet. I danced with David Drew (Royal Ballet) and talked to Anthony Dowell, no doubt embarrassing the shy young man. I also accepted an engagement to stage Swan Lake in Elmira.

The day I got back to classes with Mme Pereyaslavec, they were full to overflowing with members of England's Royal Ballet, who were performing a long season at the Metropolitan Opera House. Mme Pere kept placing me in the front line with the Royal Ballet ballerinas, who were very complimentary about my dancing, making my confidence rise and my dancing get even better. One day, Georgina Parkinson, one of the ballerinas, grabbed me after class and dragged me into one of the small studios. She said she wouldn't let me go until I taught her how to turn three pirouettes. We worked for quite a while, but she finally achieved her goal and I felt good about what we'd accomplished.

One evening, my roommates and I went down to Greenwich Village to hear some jazz at the Village Gate and to meet some of the performers from the Hip Bagel next door. That's when and where I met the as-yet-unmarried Bill Cosby. He asked me for a date and we had dinner and went to Birdland for jazz. I told him he shouldn't take me out for dinner again as he made me laugh so much with his funny stories that I really couldn't eat, so from then on, we just went to Birdland. As he got more famous and did the Tonight Show on TV, he would invite me to the Green Room, where I met the other celebrities appearing on that particular show. He always called me "The Ballerina" and was the nicest, most polite, gentlemanly young man. I still can't believe what's happened to him, the awful things they say he did later on in life. Can people really change that much?

With my Unemployment running out, the Compensation hearing constantly being delayed and no work in sight, I was very worried about money, but I kept taking classes and found my social life improving as, with no rehearsals, I had more time to explore it. I bought Helen Gurley Brown's

book "Sex and the Single Girl" and started implementing her ideas. They were working! Jack Cassidy invited me to the Broadway show he was starring in, She Loves Me. I had supper at Danny's Hideaway, a restaurant frequented by performing artists, with Earl Holliman. Tom Competello, an actor/director from the Actor's Studio, asked me out on a date. Oh, and I married Manuel Galan, a Spanish dancer, in order for him to get his green card so that he could take care of his twin dancing sisters. Six months later I flew to Mexico for a divorce. You could do that in those days. Manolo got his green card and I got a beautiful life-sized portrait of myself in my Don Quixote costume and delicious dinners every night that I posed for him. I also went out with Jack Cassidy and Ray Walston and, back to Danny's Hideaway for dinner with Red Buttons, Jim Backus, and Jack E. Leonard, all of whom were very nice and very funny.

At last, a phone call from Walter Terry got my dancing life back on track. Tommy Andrew had been contracted to choreograph a piece for the Harkness Ballet, and he wanted to do the preliminary work in New York before flying off to the Riviera to set it on the company. He used me in a pas de deux with Billy Glassman from Ballet Theatre. The piece was good, and the contract was, too. We rehearsed for several weeks, and Tommy also rehearsed me in The Still Point. America Dances was going to open the new Delacorte Theater in Central Park! Arnold Spohr, Artistic director of the Royal Winnipeg Ballet, called to ask again if I would join the company as its ballerina. I had to say no because rehearsals were to start the week of our Delacorte performance, and he wouldn't let me fly in for that and fly back to Winnipeg the next day. Also, Laverne Meyer, Ballet Master of England's Western Theatre Ballet, came to watch Tommy's rehearsal one day and thought I was "marvelous"! He wanted me to join his company – my dream of performing in Europe could have come true, but I felt a loyalty to Tommy and Walter that wouldn't allow me to leave them. Besides, they told me their new company, Ballet Today, would star Marjorie Tallchief, George Skibine and ME!! And that Clarissa would be in the repertoire.

Life Magazine did an article on the upcoming dance performances at the new Delacorte Theater which would feature excellent companies and free tickets. America Dances was front and center in the photo and the Joffrey Ballet was way in the back – YES! The performance went very well for me: Gloworm was a hilarious success, Invitations was only fair, but The Still Point really captured the audience, even the people sitting behind the stage – all were really moved. My reviews were excellent and Mother, Dad, and Grampy were proud. Manolo was supposed to gift my parents

with the portrait of me, but he said it wasn't finished: he had to repaint my face as it was in performance, not as it is in everyday life. I treasure that portrait as it hangs in my house to this day.

Mme Danilova was again our MC, but Ruth St. Denis finally joined us for this performance. I had seen Martha Graham too late in her career and had decided not to watch Miss Ruth in order not to be as disappointed in her as I was in Graham. I knew I was right when two "acolytes" practically carried her into her dressing room, slathered her with make-up and wrapped her in a sari. All this time she neither moved nor spoke. However, Tommy forced me backstage to watch her do her famous dance "Incense." She leaned her brittle body very heavily on me as she removed her slippers and plodded to her entrance wing. Then – magic, absolute magic happened. She danced like a young person with liquid movements of her arms. Oh, she was glorious! Afterwards, she leaned her brittle body very heavily on me as she slipped her feet into her slippers and waited for the company bows which would close the show. WOW!

Several more performing experiences included filming Tommy Andrew's Harkness ballet in Watch Hill, which turned out to be fun: a train ride, dinner, a hotel stay and the filming itself, all under the aegis of Jeannot Cerrone. Besides that, Tom was choreographing the season for the New York City Opera, for which I was the prima ballerina. I was also guesting with the Garden State Ballet in their Nutcracker and excerpts from Raymonda. The problems? Ramon and I had to be on the bus to New Jersey every day at 6:30 a.m. for one or two performances and some rehearsals. Then back to New York for rehearsals at City Center with Tommy and performances of the operas. I did Le Rossignol, Louise, The Merry Widow, Die Fledermaus, Manon, Ballo in Maschera with NYCO, and La Traviata (with Joan Sutherland) with the Philadelphia Lyric Opera. I was also preparing a performance at Shaarei Tefila, "my" synagogue, with Earl Sieveling of two pas de deux, and one of Swan Lake with Jamie De Bolt in Elmira, as well as doing notes preparatory to teaching Scheherazade for Lucille Stoddart's Dance Congress. Classes, rehearsals, traveling back and forth to Philadelphia and New Jersey, as well as searching for, finding and moving into a new apartment. I was exhausted!

I was also staging ballets for the Joffrey Ballet and teaching company classes there. One day, a young man came to me before class and asked if he could join the class. He was going to do some performances of Frederic Ashton's A Wedding Bouquet and had a rehearsal that afternoon. Before class began, I asked him if he wanted me to correct him or if he'd rather simply use the class as a warm-up. He said, "Just treat me like all the other students." He tried to do everything I

asked for and was beautiful to watch. Afterward, he asked if I could stay a few minutes to work with him so that he could be sure he understood all my corrections. When I'd dressed and was taking the elevator down, two apprentice boys were talking. One said, "Did you watch Anthony Dowell? He took class like a student, not a professional dancer." I interrupted, saying, "No, he took class exactly the way a professional dancer should. That's why he's one of the greatest dancers in the world, and your attitude is why you'll never get into the Joffrey Ballet." Neither of them ever did have a career as a dancer.

In the middle of all the above, President Kennedy was assassinated and I spent time mourning my first president. Our Swan Lake performance in Elmira was postponed, although I had flown up there: the airline flight personnel had been instructed not to let me get on the plane, but they forgot, so I shocked Halina and Floyd Lutomski with my arrival. I taught Scheherazade, learned and performed more operas with Tommy and had to find a new partner when Mr. Balanchine rescinded his permission for Earl to dance with me at the synagogue at nearly the last minute. All went well, thank heavens and, at the end of the year, I met the love of my life at a Singles' Brunch at Temple Shaarei Tefila. He happened to sit directly across from me, and I thought "I'm a ballerina, so I'm never getting married, but if I were, that's the guy." And he was – 58 years, three children, six grandchildren and two great-grandchildren later.

Several performing opportunities next presented themselves: I got a chance to dance – and sing – in the Gilbert and Sullivan season at NYCO. Gilbert and Sullivan didn't want ballet in their operettas, but the Director, Dorothy Raedler, a G&S expert, decided to make use of me anyway. Tommy had negotiated a ballerina contract for me, so Miss Raedler looked for ways to use me. Iolanthe was a no-brainer, as one of the Bumble Bees was mute and Tommy choreographed a funny dance for me. Likewise, The Gondoliers, in which there is music for a danced Cachucha, but Patience required real creativity to find a place for me. The piece opens with "Twenty Lovesick Maidens" singing, and Miss Raedler decided to hire nineteen and use me as the twentieth. She also reserved music for me for a danced "Bunthorne's entrance," which she let me choreograph. It was just a few measures long, but it got me a wonderful review in the New York Times!

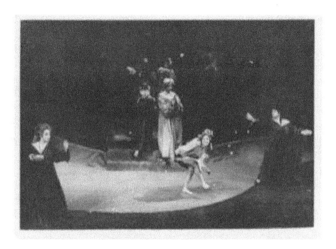

"Patience", Bunthorne's Entrance

Since I was in a solo dressing room, I didn't see what the other ladies were doing with their costumes, but it looked to me as if there was something "off" about mine. I decided to do exaggerated make-up, stack the too big flowers on top of my head and disarrange the neckline. When I arrived onstage, I was shocked to see the other ladies looking bejeweled and glamorous. The overture started at the dress rehearsal, and the curtain rose on us singing. Not for long. We heard a scream and someone yelled "Stop!" Ruth Morley, the costume designer, leapt onto the stage and berated the other nineteen ladies, "What's wrong with you? Couldn't you tell that the costumes are supposed to add to the comedy of this piece? Rochelle is the only one who understands what I was trying to do. Go upstairs and do what she did!" Orchestra rehearsals are expensive. The conductor wasn't happy.

Tommy wasn't the best partner: he put all his strength into his hands and fingers and not much into his upper arms. The result was bruised ribs and hips with his fingerprints making visible bruises. One night I awoke in terrible pain. I couldn't breathe. I called my doctor who sent an ambulance to my apartment and said he would meet me at the hospital. While we were riding there, at 2 a.m. and with no traffic on the streets, I asked the driver if he would turn on the flashing lights and the siren. After all, I never expected to ride in an ambulance again – little did I know. But I didn't stop to think what my fiancé, who was driving behind us, would think. When he got to my room at the hospital he was white as a ghost: he thought something awful had happened to me! I was diagnosed with a collapsed lung and had to lie in bed at a 45° angle for a few days. The lung finally reinflated by itself, which is what the doctor wanted. He said it would be stronger that way. Good thing, too, because Ramon and I were scheduled for a performance of pas de deux, with

orchestra, in Queens, NY. It went well, but it was still hard for me to breathe. My fiancé tried to "correct" my make-up until I threw him out of my dressing room!

Student Prince

Right after Bob and I were married, Joyce Trisler asked me again to do a summer stock project, with Nels Jorgensen as my partner. We did <u>The Student Prince</u> and she choreographed a lovely pas de deux for us. Problem: I got some sand from the beach in my eye and it scratched my cornea. The doctor said I was not to wear my contact lenses for several days. That's a major problem when you're dancing in a tent that has six aisles down (or up) from which you enter and exit. I had no idea where I was half the time, but dear Nels managed to get me on and off stage at the right time in the right place. My husband gave me the $15 for my room, but when he came to see me on the first weekend, I told him I didn't need any for the next week. When he arrived the next weekend, I gave him money back. He said, "I'm not going to ask you what you've been doing to earn this…." I'd actually lent Nels money, and he was paying me back. That's where I got the money.

The lecture/demonstration in Richmond led to a TV program called "Today's Dancer," which featured Michael Maule, Walter Terry and me. When my Bob dropped me at the TV studio, we asked how long the filming would take.

"About ½ hour."

Since the program was to be ½ hour long, I immediately got nervous.

"You mean we're not going to be able to reshoot if things don't go well?"

"They never do!"

Fortunately, everything went well and it was a lot of fun to do.

I also did some performances at Caramoor in Katonah, NY, of Carl Orff's opera Die Klüge. There were three dancers, myself and two young men, and we were in eleven scenes. The problem: the stage was a four-foot high wooden platform resting on concrete, and we had to jump off the stage into the wings after each scene. Once, when I landed, I felt a twinge in my left ankle, but I thought nothing of it. When I got back home I was scheduled to be a ballet mistress for the Joffrey Ballet until the next NYCO season, which was to be our first at Lincoln Center. On my first day back, my ankle really hurt, so I told Mr. Joffrey I was going to the doctor and would be back soon. As I was leaving, I heard the Pas des Déesses music being played in one of the studios. I poked my head in and saw Nels Jorgensen rehearsing the ballet. One of the steps wasn't quite right, and I asked Nels if I could help. I did one small jump, heard a noise as if a piece of wood had snapped, felt as if a floor board had broken, saw a hole in my leg just above my ankle, and sat down on the floor. I had torn my Achilles' tendon. I was taken to Le Roy hospital where I received a message from Joffrey telling me not to go home from the hospital when they released me, but to come to the studio to be the Ballet Mistress of the Joffrey Ballet until I could dance again. As it turned out, I never could dance again, so my new career, and my new life, began immediately.

That new life turned out to be even more rewarding and exciting than the years of dancing had been. In addition to teaching and choreographing, it involved living and working all over the world, finally getting the education I had denied myself when I left school so young, and marrying and having a family. But that's material for Book Two of **Have Tutu, Will Travel**. See you then!

Glossary

Défilé: Spectacular presentation of an entire company, starting with students, ending with leading dancers.

Gargouillade: "Gargle with the legs", the last step I learned, the step on which the leading female role in George Balanchine's "Square Dance" is based.

Rond de jambe en l'air: Circle of the leg in the air, extend one leg front (or back) at 90°, circle it side and back (or front), also at 90°.

Pliés: Knee bends

Battements tendus: Stretched movement of the feet on the floor.

Pas de trois: Dance for three

Demi-caractere ballet: A ballet based on characters rather than on abstract technique.

Pointe: Toe work, standing on extreme tip of toe; demi-pointe, half-toe not on pointe.

Penché arabesque: Bent forward in arabesque position.

Arabesque: One of the fundamental positions, where the body is in profile, supported on one leg, the other leg extended behind at an angle of 90°.

Échappé: Designates a movement from a closed to an open position.

Cygnets: Little swans

Pas de deux: Dance for two, usually consisting of an entrée, an adagio, two variations and a coda, may be part of a ballet or a stand-alone dance.

Czardas: Hungarian dance

Pirouettes: Turns on one leg

Premier Danseur: First dancer, leading male dancer.

Matinée: Afternoon performance

Soirée: Evening performance

Fouettées: Spectacular turns on one leg while the other does a whipping movement.

Finger turn: Ballerina holds the downward thrusting index finger of male partner and spins on one foot as the other leg performs a whipping motion.

En Travestie: Man in female dress, or woman in male dress.

Printed in the USA
CPSIA information can be obtained
at www.ICGtesting.com
CBHW040900300324
6114CB00028B/1541